THE SECOND PARTICLE WAVE THEORY

(AS PERFORMED ON THE BANKS OF THE RIVER WEAR,
A STONE'S THROW FROM S'UNDERLAND
AND THE DURHAM CATHEDRAL)

JIMMIE DURHAM

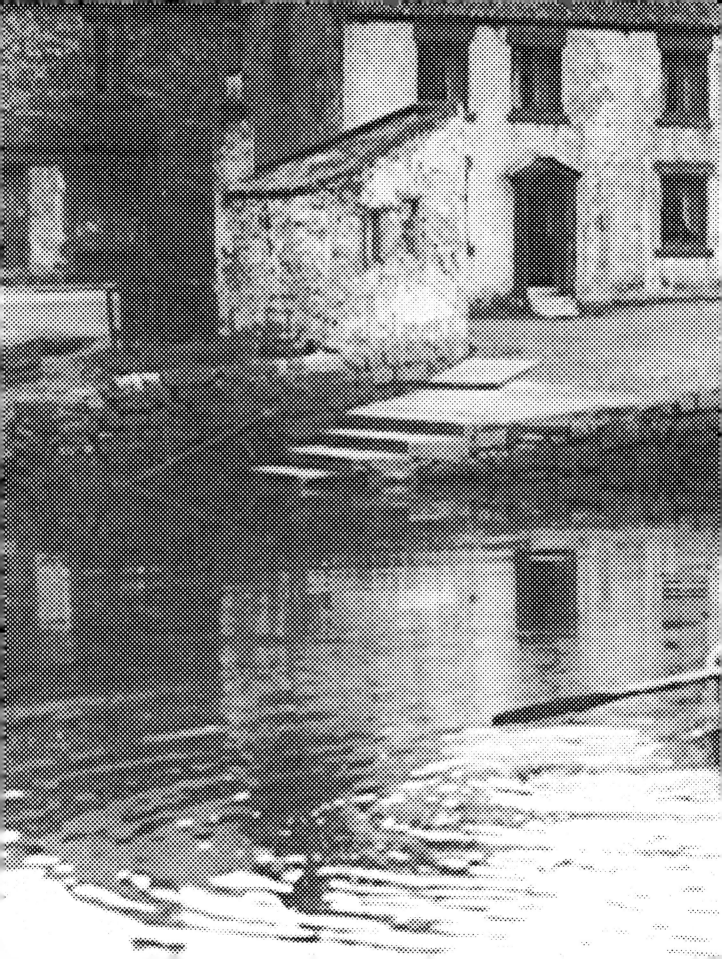

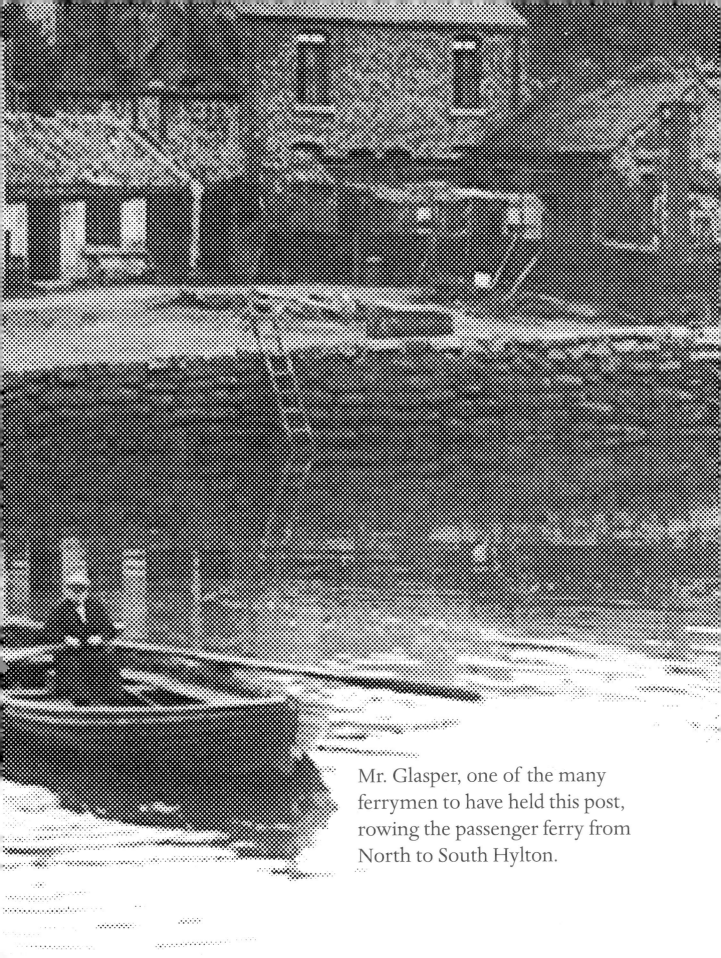

Mr. Glasper, one of the many ferrymen to have held this post, rowing the passenger ferry from North to South Hylton.

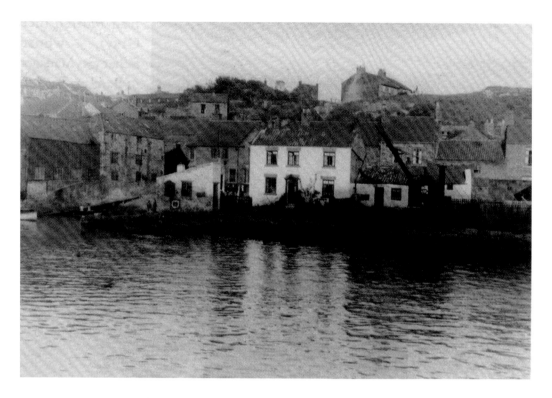

The riverside with the ferryboat landing with Wigham's works on the far left and the present Golden Lion to the rear of the ferry landing waiting room.

CHORAL SERVICE ON A MIGHTY ROCK.

COMBINED CHOIRS SING ON THE FAMOUS ROCK IN MARSDEN BAY.

One of the grandest similes used by the Psalmist to set forth the might and majesty of God is that of a rock. Standing alone in all its strength and grandeur, few natural objects are more awe-inspiring or suggestive of Almighty power. It is no wonder, therefore, that the huge rock which stands and stands majestically in the bay. Although surrounded by water at high tide, it can be reached across the sands at low tide, when the numerous arches, worn out by the action of the sea, can be explored. On one side, to the left of the picture, a long ladder has been fixed, and after

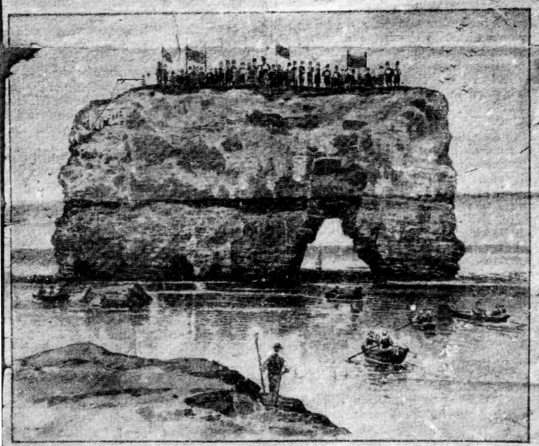

A REMARKABLE MUSICAL SERVICE. COMBINED CHOIRS SINGING ON THE MAGNIFICENT ROCK IN MARSDEN BAY.

In Marsden Bay, almost midway between the Rivers Tyne and Wear, should appeal to sacred singers as a suitable place on which to sing praises to the Eternal Father.

Our picture on this page shows such a gathering of combined choirs on this noted rock, and the service was one never to be forgotten.

The huge Marsden Rock is separated by some thousand yards from the mainland, scaling this an ascent can be made up the sides to the top of the great rock.

On a recent occasion combined choirs met and sang a number of musical compositions upon the top of Marsden Rock. The effect was most inspiring to the listeners, as they stood on the high cliffs of the mainland, and heard the great swell of choral praise floating over the wide waters and ascending to heaven.

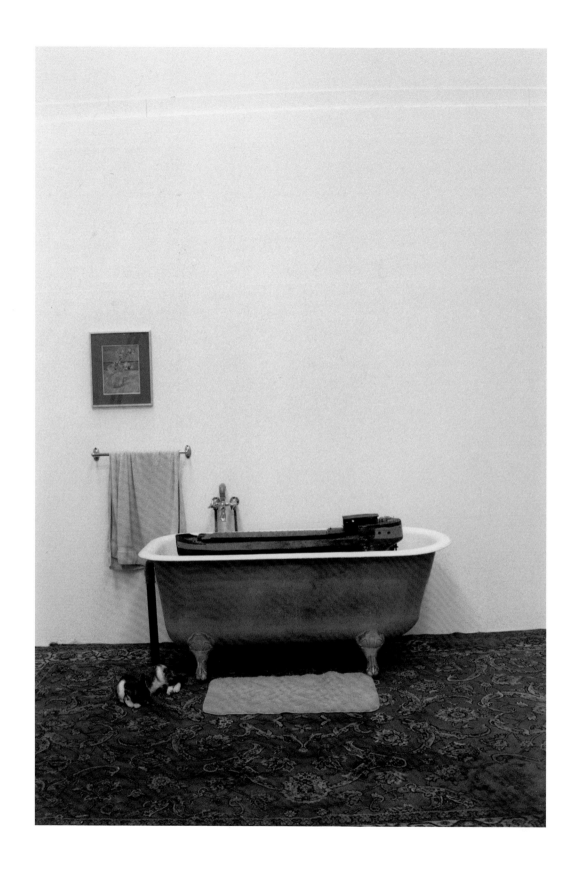

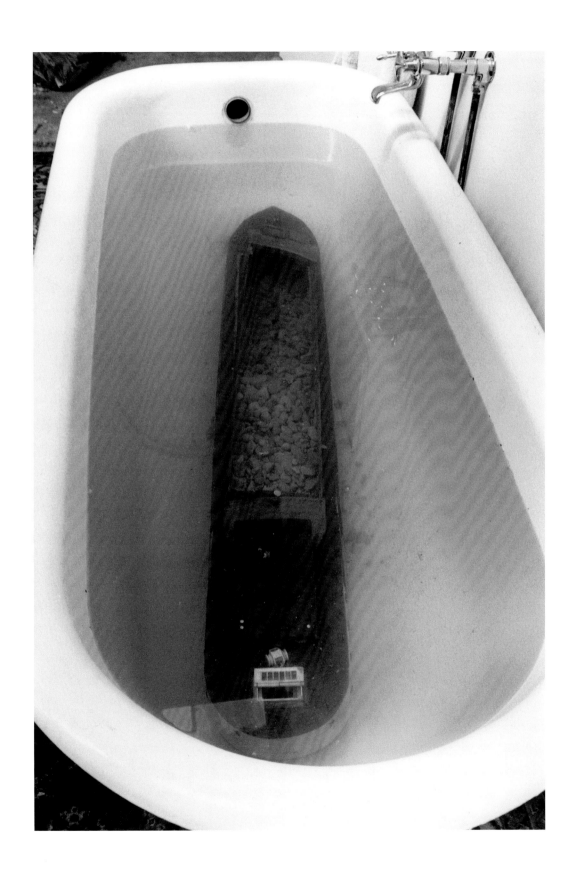

Jimmie Durham

University of Sunderland

SCHOOL OF ARTS, DESIGN, MEDIA & CULTURE
ASHBURNE HOUSE
BACKHOUSE PARK
RYHOPE ROAD
SUNDERLAND SR2 7EF
UNITED KINGDOM

TEL: 0191 515 2112
FAX: 0191 515 2132

June 22, 2004

Dear Jimmie,

We (Candice Hopkins and Rob Blackson) have admired your work since we found about it in art school. Since then we have become curators and are working in Canada (Candice is the Aboriginal Curatorial Resident at the Walter Phillips Gallery) and England (Rob is the curator at the Reg Vardy Gallery at the University of Sunderland). We have been quietly scheming for years about ways of inviting you to participate in a solo project or exhibition.

To this aim we have come up with four 'distractions' that we hope might interest you. We have decided to call them distractions because during your lecture at Bristol University earlier this year (where Rob briefly introduced himself) you mentioned that your preferred method of working was going from distraction to distraction.

Should any of these interest you, the Reg Vardy Gallery would like to offer you an exhibition in either the autumn of 2004 or winter/spring 2005. This opportunity would also come with an option, if you choose, of a distributable bookwork. The Walter Phillips Gallery would then offer to tour the distraction in 2006.

Please do not internalize these as ultimatums, but rather as seeds.

1. In *Between a Rock and a Hard Place* you speak of a project where you would like to "free some stones." We were wondering if you would be interested in freeing some artwork. The project could be a collaboration with a permanent collection lent to the gallery for the purposes of the exhibition (the Reg Vardy Gallery does not have a substantial collection of its own but has access to one that does). You would not necessarily be a curator of the exhibition but a collaborator of sorts. There is the potential to make a work in relation to these works some of which are old and monumental, kind of like architecture itself.

2. On the topic of freeing stones, you have mentioned sinking a barge with some stones. Sunderland is on the west coast of the UK where there are boats (if not barges) and lots of stones...

3. You have described yourself as an orphan. Upon reaching maturity many orphans try to locate their parents or place of origin. Appreciating your last name and the nearby town of Durham (Sunderland is twenty minutes away) there might be a lineage between the two.

4. During your discussion earlier this year at the Situations talk with Claire Doherty you mentioned that you are very grateful for surprises. As an example you mentioned a specific piece of classical music, perhaps by Mozart, whose arrangement surprised you. Such surprises, you inferred, always goad and

INVESTOR IN PEOPLE

PROFESSOR FLAVIA SWANN
BA FRSA
VICE-CHANCELLOR AND CHIEF EXECUTIVE
PROFESSOR PETER FIDLER
MBE MSc DipTP DipSoc MRTPI MInstD

encourage you not to be stupid. We found your admiration for these seemingly fleeting moments of clarity to resonate with Italo Calvino's writing from *The Approved Dustbin*:

"All that's left to me and belongs to me is a sheet of paper dotted with a few sparse notes, on which over the last few years under the title *La Poubelle Agréée* [The Approved Dustbin] I have jotted down the ideas that cropped up in my mind and that I planned to develop at length in writing. *theme of purification of dross throwing away is complementary to appropriating the hell of a world where nothing is thrown away one is what one does not throw away identification of oneself rubbish as autobiography satisfaction of consumption defecation theme of materiality, starting again, agriculture world cooking and writing autobiography as refuse transmission for preservation* and still other notes whose thread and connective reasoning I can no longer make out. *theme of memory expulsion of memory lost memory preserving and losing what is lost what one hasn't had what one had too late what we carry around from the past what does not belong to us living without carrying around anything from the past (animal): perhaps one carries around more living for the work one produces; one loses oneself: there is the work that doesn't work, I am no longer there.*"

Perhaps there is a way of collecting these surprises into a likeness without losing oneself.

SUNDERLAND

We are not sure what you know about Sunderland: probably more than us, but in any event we dug up some facts. Take them as you will.

*Six men took part in a pole-squatting competition at Seaham Colliery in 1933 — some of them stayed there for 48 hours.

*During WWII Sunderland was heavily bombed. This was not due to Sunderland's value as an enemy target. It was simply the last city the Luftwaffe flew over before heading back to the continent. By default, Sunderland became the dumping ground for any bombs the Germans did not use on their scheduled missions.

*A violent ice-storm raged in Durham in July 1792, when the streets were covered with ice two-feet deep.

*Bull-baiting was regularly practiced on The Green, Bishop Wearmouth, with the last occasion being on May 28, 1822.

*The Venerable Bede studied at St. Peter's Cathedral in Sunderland. The Venerable Bede is credited as the inventor of the 24 hour day and promoted the division between BC and AD time keeping. He was also the first to record a history of England. His tomb is in the Durham Cathedral.

*The first author to mention the River Wear in his writings was the Egyptian historian Ptolemy in the First Century AD.

*The "Pancake Bell" was rung in Sunderland every Shrove Tuesday at 11am as a signal for local people to begin frying their pancakes. The custom stopped in about 1876.

*Up to three centuries ago, it was the custom in Sunderland to light fires in the streets on Midsummer Night and for men and women to leap through the flames.

*"Buffalo" Bill and his Wild West Show visited Sunderland on July 18, 1904. The

show was held at Lane Ends Farm, Hylton Road, and needed three special trains for its 800 people and 500 horses. A lion from this show died while in Sunderland. His body was stuffed and is now on exhibit in the Sunderland Museum.

"Although the greater part of Sunderland lies to the south of the Wear some of the oldest and most historic parts of the modern town are on the northern bank of this river. Undoubtedly the most historic part of Sunderland is that area on the north bank by the coast called Monkwearmouth. Sunderland was originally part of Monkwearmouth and in fact the name Sunderland derives from 'Sundered Land', that is land that was sundered or separated, from the monastic estates of Monkwearmouth in Anglo-Saxon times. For centuries Sunderland was only a part of Wearmouth and although the name Sunderland was commonly used for the whole area, it was not until 1719 that Sunderland itself achieved the status of a separate parish. In 1897 roles were finally reversed and Monkwearmouth officially became part of the town of Sunderland."

REG VARDY GALLERY

Tucked within historic Ashburne House and overlooking Backhouse Park, the Reg Vardy Gallery produces seven exhibitions each academic year. This programme enables artists to experiment and develop new work for the context of the gallery, explore curatorial issues and consider a range of ideas around contemporary culture. The Reg Vardy Gallery also provides an informal space for debate through a range of events and open discussion for the artistic, academic and regional audience.

We are looking forward to your response. Again, please take these ideas as a beginning. We are flexible and will do what we can to accommodate your interpretations of what we have posed above. As each of these projects is quite different we can discuss your fee and other details once you have had a chance to consider this proposal.

It would be an honour to work with you on this project.

Sincerely yours,

R o b

Rob Blackson & Candice Hopkins

44 191 515 2128 (Reg Vardy Gallery's phone number from Berlin)
44 191 515 2128 (fax number, please put to the attention of Rob Blackson)
robert.blackson@sunderland.ac.uk
Candice_Hopkins@banffcentre.ca
www.regvardygallery.org

CHAPTER ONE

Some notes on materials used.

1. ENGLISH WORDS

Readers may notice that, even though this is an 'art book', it does contain quite a few English words.

English words were invented by a guy named Wulf, later known as the Venerable Bede. (Of which, more later.) Wulf was the only child of Geirthrudir, who, despite the name, was not Danish nor Anglo-Saxon. She was known for her wavy, dark red hair, which hints that she may have been Celtic.

Wulf had no registered father and Geirthrudir died when he was three years old. Initially he was then given to Geirthrudir's aunt (the older sister of her mother; the two younger sisters had disappeared some years earlier), Aethelbeortha, who was almost fifty years old at the time and died within the year.

For the next two years the child was essentially homeless. By the time he was five years old he could speak several dialects, including the rough Latin of the area, and Geordie.

Wulf was quite small for his age, probably due to insufficient food. In those days England had no potatoes, no beans or tomatoes. Beer was imported from Copenhagen and Dublin, a Danish town in Southern Ireland. But he was also quick and charming. There was a Christian monastery close to the mouth of the Wear River which flows down from the Pennine Chain of mountains, which themselves butt up against the Cheviot Hills, causing a drainage which becomes many rivers. (Please do not confuse the Pennines with the Pennine Alps of Switzerland; I have been unable to find out why they have the same name. It may be coincidence, like a guy named George in Geneva and another George in S'underland; even though they both have mothers of the Caucasian race [that is, originating in the Caucasus Mountains, which are situated just east of Europe proper] they are not necessarily related. It is just a quirk of words. But we might, since they are both of the 'White' race, call each of them 'White George', which I would like to do because it gives opportunity to mention 'Yellow George'; not a cowardly king but a half-crown, which was an English unit of currency also called a 'Guinea'. In the US 'Guinea' is a racist term for someone from Portugal.)

In time, with great patience, Wulf talked the monks into taking him in. By that time he was seven years old. They gave him the nickname 'Bede', which means both a small prayer. (It comes from the same word as 'bid', as in, "I bid you to give me some bread.", or "I forbid you to eat that bread", or "You must do my bidding". But 'Bede' also means a bead, because the monks had strings of beads for saying their prayers. Each bead represented a prayer, and so was called a prayer, a bead.)

It was much later, of course, that he became 'Venerable'. It has the use of meaning 'honour-able', but really does not come from the 'honourable' family. Its family include 'venereal', 'venison', and 'Venus'. The root, or grandmother, to keep the family metaphor, means 'that which is desirable', therefore also, 'that which we hunt', hence, 'venison'.

The V. Bede lived his life in pre-S'underland and wrote many books in English. For readers in Cornwall, Australia, and the English colony off the coast of Argentina who have never heard of the Wear River, S'underland, or even the Durham Cathedral close by, I hereby explain that they are all in England; somewhere in the north of England, by Newcastle and Scotland.

Any reader might ask why, just because I am using English words, I feel a need to bring forth the words 'race' and 'racism'. OK, The Venerable Bede was quite racist against Celts. Maybe too much. Maybe he was a closet Celt and needed the psychological defence.

Readers may notice that words on paper often contain insufficient meaning on their own. The English have devised, therefore, (please wait a moment for this important diversion within a diversion; the word 'therefore' reminds me of the word 'wherefore' and a grating problem I have with the literate cultured English: In a play by William Shakespeare a young woman calls out, "Romeo, Romeo! Wherefore art thou Romeo?" For reasons beyond logic actors usually assume that 'wherefore' is just a long 'where', which leaves Juliet asking Romeo where he is. 'Wherefore' is a Danish version of the modern English 'why', not 'where'. She is asking "Why art thou Romeo?" As you may know, both these two young people feel caught in the trap of identity. "Would not a rose, by any other name smell as sweet?" we are rhetorically asked.

When spoken, the line, "Romeo, Romeo, wherefore … etc", should have the emphasis, the accent, on the word 'wherefore', not on the word 'art'. Thank you.)

— the English have devised, therefore, a system of symbols for written English, to help us make sense of sentences. Included among these are commas, question marks, and what American speakers call a period, but which I think the English call a full stop.

I believe there is room for improvement there. Like William Blake, "I will not stop from mental fight, …till we have built Jerusalem in England's green and pleasant land." I offer the following suggestions only towards clarity. As things stand, we may underline a word in a sentence if we want to give it greater emphasis. <u>If</u> we want to give it greater emphasis, for example, well all we need do is take logic into service and add the concept of overlining. If a word in a sentence requires less emphasis than the others, we simply put a line over it. Here: "Romeo, Romeo, wherefore a̅r̅t thou Romeo?" (In print, underlining is often substituted by the use of Italic type, so overlining in those cases could easily be substituted by Bold type "…,…eo, wherefore **art** thou….o?" would mean to go softly on the '**art**'.)

"I am leaving!" The exclamation point makes the sentence, doesn't it? But what if we want to show the opposite? Someone who is leaving without a care in the world: " ¡ I am leaving too,"

SOME ENGLISH WORDS

OAT

STOAT

COAT

GOAT

MOAT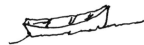

FLOAT

BOAT

GLOAT

BLOAT

MORE ENGLISH WORDS

Ear hear clear bear near rear fear tear gear!

Punk sunk hunk, clunk! junk, gunk! (Bunk drunk funk)

Big pig rig, dig? (fig-sprig wig)

Gun fun, sun. Run!

MAKE YOUR OWN ILLUSTRATIONS!

works perfectly well, doesn't it? It shows you right up front to expect little, to be ready for calm.

The same is true for the question mark. There can be statements which support no doubt at all. An inverted question mark at the beginning would serve notice to everyone that the statement brooks no argument: "She left?" "¿She left" or it might be more aesthetic to cross out the question mark, the way the names of towns are crossed out as one's vehicle approaches the far border. ~~DURHAM~~. "He left~~?~~"

(I also feel that a case can be made for the single parenthesis.

Some words lead to objects. Although there may be wood in this book, as I am now about to mention wood as a material, I mean the wood of which the poor sunken, mis-used and degraded boat in the Wear River, waves lapping over its gunwales every high tide, is made. It is made primarily of oak. Next to bois d'arc and mesquite, oak is the most noble wood.

The word 'oak' originally meant 'tree'. As though only an oak was a true tree. But there is more; originally the word 'tree' meant only an oak tree. And the word 'true' comes also from that root. Truth is an oak tree.

2. WOOD

The boat in the Wear is made mostly of oak. It could last a long time, comparatively; some 'bog oaks', oak trees that have been sunk in bogs for thousands of years, are perfectly preserved. But that is because of the special acid found in peat, which is compacted sphagnum moss. Even iron, extracted from ore or meteoric iron that has soaked in peat bogs or streams, is improved by this acid. The iron is less liable to rust.

If you run (non-chlorinated) water over peat the water makes a good flavouring for distilled fermented barley mush. This drink is called Scotch, and in some places it is poured over stones, particularly on Manhattan Island.

Surely it is possible now to produce this flavouring synthetically, however, using the latest scientific knowledge of esters, resins and petroleum polyester resins. So many things can be made of petroleum now that we wonder what it really is in the first place. Do you think that dinosaur juice contains so much stuff because the world was more varied in those days or because of the opposite?

("O, possibly it was the opossum opposite to me", is the first line of a poem I've been working on for some years.)

Here is some real science:

It gives me great pleasure to use this book to announce a new scientific discovery which I have made. I'm not sure why, but already I feel that the reader is getting ready to smile. (Although perhaps with impatience with what he or she perceives will be one more attempt at humour.)

Please be assured, reader, that what follows is straight-forward, sincere. (Even though the English language makes things sound funny when it says "following straight forward") I am not a scientist simply because I have not enough time. I nevertheless observe nature constantly and scientifically as well as reading, however lightly (but necessarily lightly, given the volume of papers published), scientific publications.

But first another small digression. Maria Thereza Alves once did a series of interviews with 'third world' people living in a European city. The questions were about their favourite plants 'back home'. I was struck by how tenderly people, men as well as women, remembered some plant. This phenomenon in itself is worthy of scientific study.

I have a favourite plant, which grows in the forest back home. Whenever I see it I feel happy. It is called, unfortunately or inappropriately, Maidenhair Fern.

Maria Thereza Alves and I have (in 2005) been partners for twenty-seven years. Her favourite plant, since she was a small child, is also Maidenhair Fern, as it grew around her village in Brazil.

This could be a phenomenological study, after Bachelard.

But it is only a coincidence to my main point.

However, we were in Kitakyushu, Japan a few years ago when we first tasted the nuts of the Gingko tree. We did not know previously that the nuts were edible.

I read in *Nature* magazine that the Gingko tree is a direct descendent of the Maidenhair Fern. When one looks one can see that the leaves are only slightly modified Maidenhair Fern leaves. All ferns produce spores on the underside of the leaves. In the Gingko, these spores become the nuts, as the entire leaf-structure becomes elongated and more separated and only the first sections produce the nuts.

We can observe the same development in many nut trees, including the Pecan, Hickory, Walnut, and Black Walnut. The leaf-structure of these trees is the same type as found in the Gingko but more developed away from the fern look. These nut trees also come directly from ferns. That is my scientific discovery.

(This section maybe should have been called 'Boat', but that the material of the boat defines it. Even a plywood boat would ply the water differently than an oak boat. (If the V. Bede's monastery had been on the Ply River instead of the Wear, would it now be called the 'Monkplymouth' instead of the 'Monkwearmouth'?)

It is a well-made boat which some local experts claim could have been made sea-worthy once more.

3. STONE

This particular (If 'particular' has to do with 'particle', how does one make a similar word from 'wave' - - - 'wavular' or 'wavulous'?) stone comes from a cold and stormy hilltop at the Shap quarry close to Shap. It is red granite and even though red granite is quarried on the spot, the quarry master told us that a glacier had brought it there from the Grampian Mountains by Tayside, down through Motherwell, the Borders and over Hadrian's Wall into Northumbria; rolling and tumbling along the way until it acquired its best shape.

A couple of years ago I did a summer workshop in Norway with five younger artists. We were at the top of a long fjord, close to a glacier. The glacier was beautiful blue, like South Pacific water. So big!

One of the artists was an Austrian, Christian Eisenberger. The name Eisenberger means 'from the iron mountain'. He got a bunch of stones the glacier had left and stuffed them inside clothes just at the water's edge. Looked a <u>little</u> like drowned people at first glance. His explanation was, "Stones can't swim."

Have you noticed in airports and street fairs how many more kinds of beautiful stones there are these days, all sawed up and polished? And then there are marketing schemes; most of these stones turn out to have therapeutic value for practically all human ailments.

Well, gold is still a good medicine to cure poverty, but probably not much longer.[1]

I once read a book about an alcoholic guy who had leprosy and would slip into an alternative universe every time he passed out. In this other universe there were giants who sailed on ships made of granite.

Mohammad Ali has a poem, "I'm so tough I wounded a stone! I made a brick sick!"

We all know that there are evil stones. They often wait just underwater, to bite the boats and ships of humans, or bonk our heads as we swim.

Where I used to teach, at the Art Academy of Malmö, Sweden, there is a cemetery next door and one grave is marked with a large natural stone. The carving on it explains that the stone itself killed the man who lies under it. He was a quarryman, killed on the job. Now the stone must guard his bones forever.

Readers have surely noticed that there are many more unscrupulous men out and about these days, not only in England but in Scotland and Ireland as well.

To be scrupulous is to have scruples. Originally, a scruple was a small stone in one's shoe. It made it more difficult to stride forward in confidence. It made people more hesitant. It is not that people placed stones in their shoes deliberately, simply that there were more scruples in the world in those days.

Years ago I wrote a poem that ended with the lines, "Trees gave seeds, and rocks encouraged."

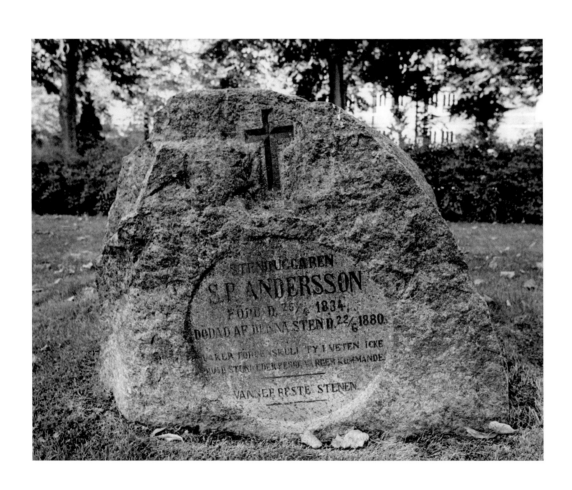

LET'S HOPE IT'S JUST
A CLOUD, AND NOT
A METEOR

← A HOUSE

← A PRETTY POND

A STONE WAS HERE

4. THE WEAR RIVER

Is it pronounced 'wear' or 'tear'? Throughout Europe cities begin to 'appreciate' their rivers aesthetically, after centuries of perceiving them only commercially. What happened to the commerce, well, I think it is kind of like a pyramid scheme, or chain-letter scheme. Industry stays in one place until that place gets to a certain level of finance, then moves on to another, poorer place. I am really not sure, though. We just need to survive the next hundred years and all the world will have gone through industrial progress and come out rich on the other side, fixing up all their rivers. Not really sure, though.

Eric Bainbridge said that when he was a young man there was hardly a way to get to the river, and no reason to.

But our river master Kenneth said that small shipbuilding firms had shipyards all the way up to where the new bridge is now. They built on the tidal shore, using stilts to support the 'yard' and thereby paid no rent to anyone. The land was all owned, as well as the river itself, but the tidal area was no-man's land.

Quite clever; we had to get permission not only from the harbour-master, but from the Queen to do our 'Particle / Wave Theory' in the Wear River. The Queen of England (I started to write something about her German family, but that sort of thing has no place in an art book.) owns all the rivers, so if one wishes to do anything beyond swimming or drowning her written permission is required.

Thank you very much, Your Majesty.

Do not fret, English people, I will not insult your Queen.

I learned my lesson in 1960. My US military ship was docked in Hong Kong and a Brit ship with the silly name of 'Ark Royal' was also in town. Alex dared me to go into a club full of limeys and shout "Fuck the Queen!" which I promptly did.

(Much water has flowed under the bridge since then.)

Even the Queen was young in 1960, wasn't she?

THE MALL,

LONDON, ENGLAND

Dear Jimmie,

So good to hear from you after all these years! Yes, of course you may use the River Wear, for whatever purposes you wish, for as long as you wish.

Phil and I have practically stopped fishing; One may now purchase a pretty good sushi lunch box from Sparks & Monsters --- I mean Parks and Spinsters, ha, ha!

I'm afraid it is not possible for me to attend the ceremonies but do send us some snaps of the boat and the large scone you'll put in it.

Will you have time to visit London? Lu Freud says that you are friends with the American artist Matthew Buckingham --- do you know that we are now living in his grandfather's Palace? Rent free, of course! You must come.

hugs and kisses,
My Majesty, The Queen

It is a beautiful, wandering river that flows through the city of Durham before it gets to S'underland and Monkwearmouth, and maybe its name means 'wandering'. The Tyne close by has a more disciplined route to oblivion into the cold (although maybe soon to be tropical) North Sea.

Have I mentioned that my grandfather was the Duke of Durham?!

English boats and ships sometimes veer off course, but they used to 'wear' in the old days, because that's how they wrote 'veer' (which means that the answer to my question is 'tear', as in "cry me a river") it is from that word that we have the word 'environment'; that which is 'around'.

I have gone once again off course, but this time we can place the blame squarely on the River Wear.

I'm sorry but may I make one more riverine digression? Johnny Cash was my distant cousin. (He liked saying that he was Cherokee, but it did not fit into his life. I'm the same.) Well, there is a beautiful English song, 'Flow gently, sweet Afton.' It is such a beautiful and famous song that a brand of cigarettes was named after it — 'Sweet Aftons'. Do they still exist? I stopped smoking in 1994. Johnny stole the tune for a song he called, 'Run softly, Blue River'. It's a pretty good song: "Run softly, Blue River, run cool and deep. Run softly, Blue River, my darlin's asleep. And if you're murmuring soothes me 'till I'm sleeping, too, run softly Blue River, we'll both dream of you."[2]

Oh, one more thing: the moon drags all the earth's water around! It is pulling our water around, making tides. It seems so unfair. But they say the moon was once part of the earth, in which instance it may be like a baby bird rejected by the parents. Yet they say that if we had not these tides life could not have developed, because the motion was necessary to stir things up.

I guess outside agitators are sometimes useful.

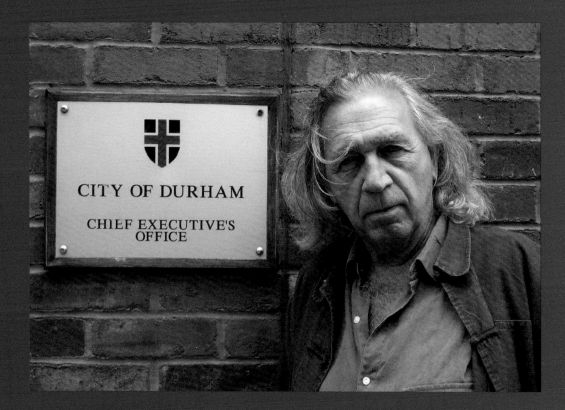

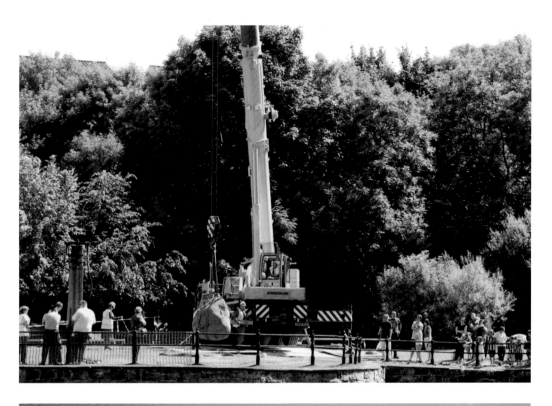

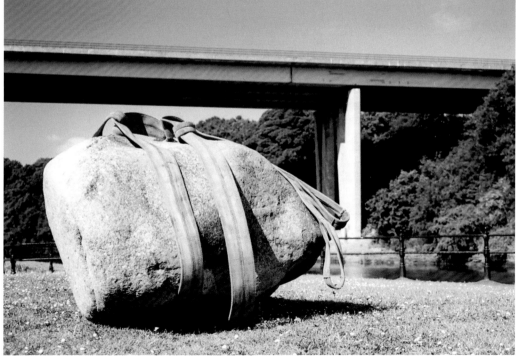

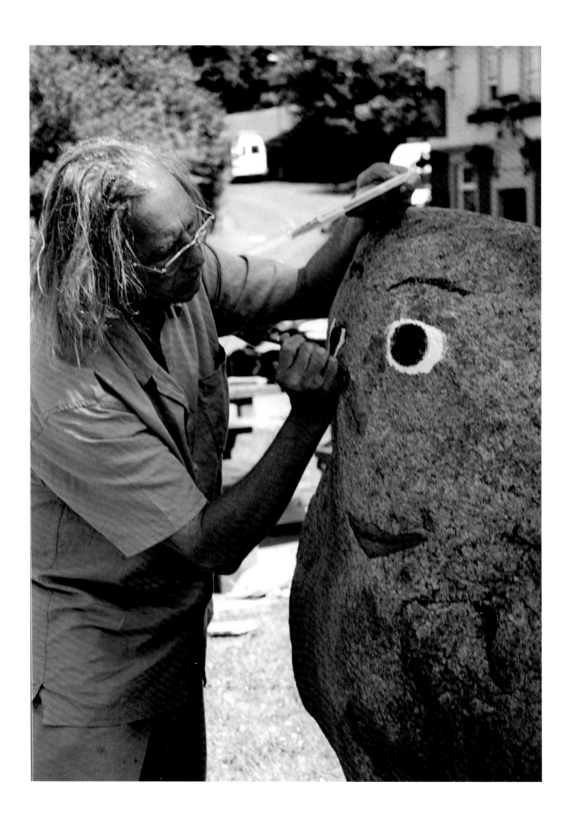

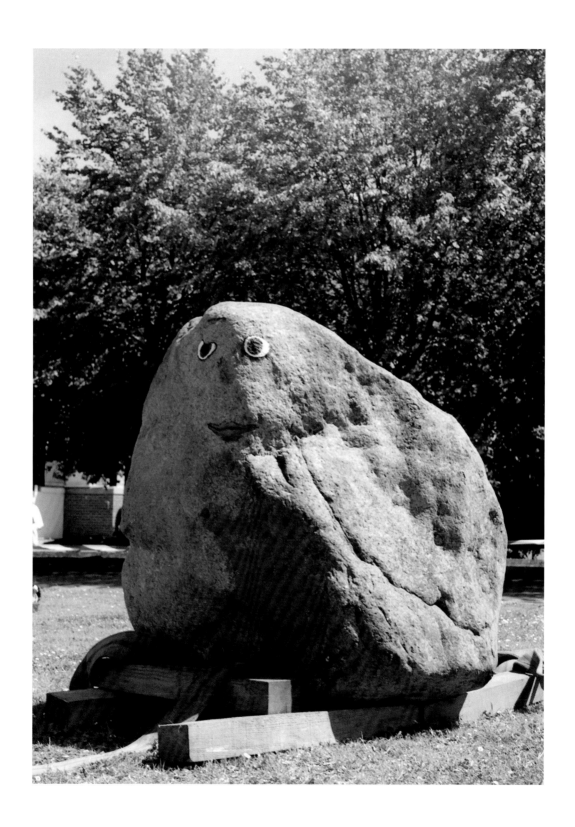

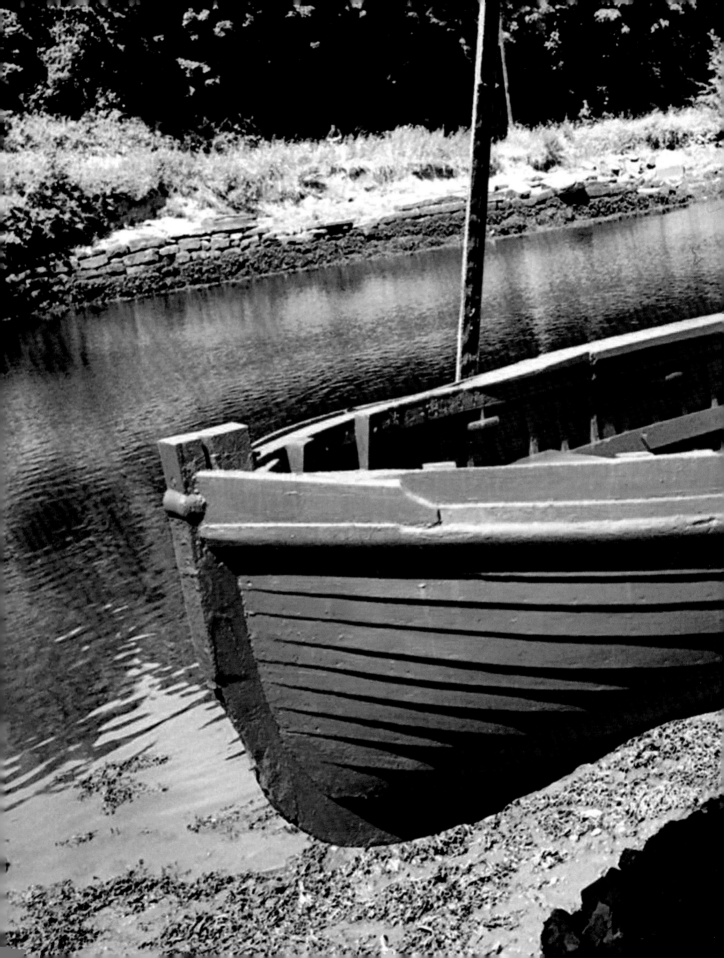

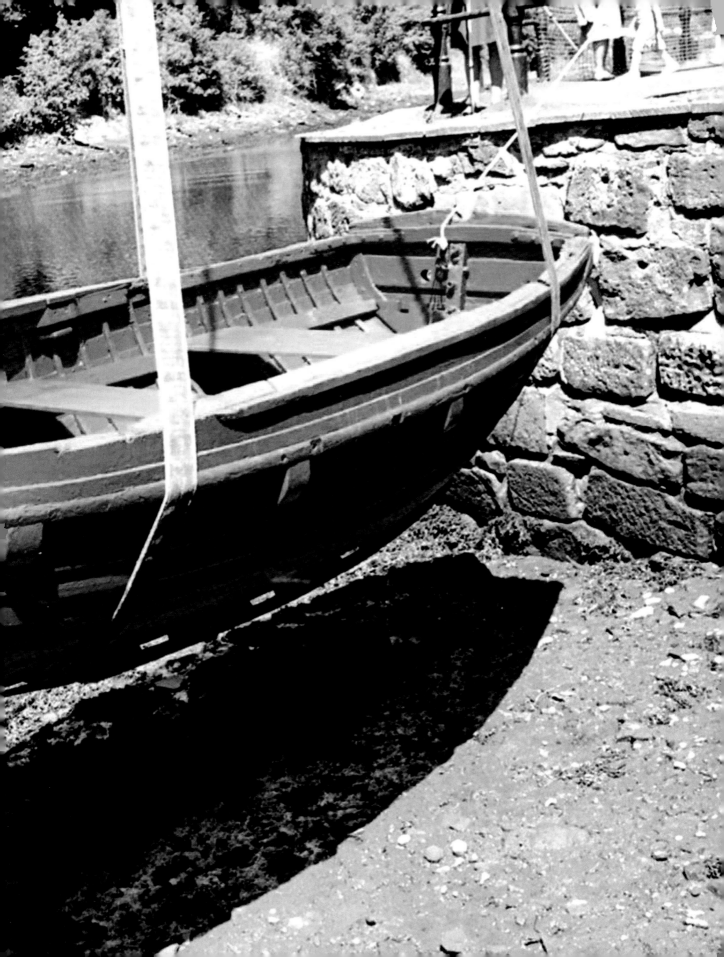

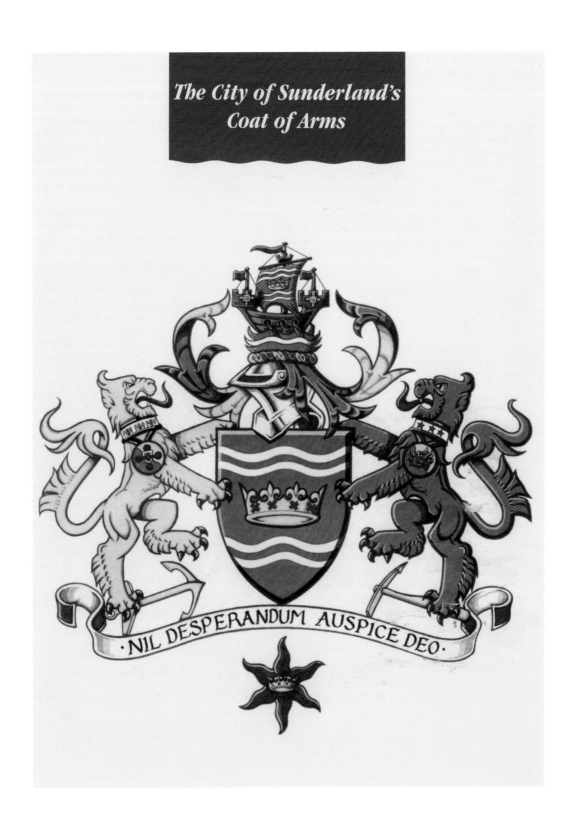

NIL DESPERANDUM AUSPICE DEO

But it was not until 1949 that the town's civic leaders decided to register a formal claim for a Coat of Arms and invited H. Ellis Tomlinson of Thornton-le-Fylde, Lancashire, to devise the town's first official Coat of Arms.

His work, which cost the town the princely sum of £160, was put on display at Sunderland Art Gallery in 1950 and it was soon obvious that some of the earlier 'unofficial' crest had been retained, though updated and formalised.

The familiar sextant on the shield still took pride of place in the centre of the crest, though this was now surrounded by a blue 'chief', the upper portion of a shield. On this was laid two cross keys between two mitres of the Bishop of Durham. These referred to Sunderland's ecclesiastical past, when the town was divided into two separate communities, Monkwearmouth and Bishopwearmouth.

The design had been carefully thought out; the keys of St. Peter clearly represented Monkwearmouth, which has its own St. Peter's Church, itself a former monastery, and the mitres were those of the Bishop of Durham, thereby depicting Bishopwearmouth.

The knight's helm had also been retained, though embellished with a slashed tournament cloak and a twisted silk wreath in the blue and white monastic colours of Durham.

The unofficial Coat of Arms had acquired a crest in the form of a terrestrial globe sometime during the 19th century. This was now replaced by a more appropriate crest, an ancient ship – in black, needless to say, to reflect the town's important coal trade. Its blue sail bore the cross of St. Cuthbert, Durham's patron saint, and the flags of St. George, the patron saint of England.

The crest was supported by two white lions and again there was a religious connection; these animals were taken from the arms of the diocese of Durham, though they also relate to the ancient kingdoms of Northumbria and Deira. They held two further emblems of the town's industry, a pickaxe and a ship's anchor, coloured gold to indicate prosperity.

The Coat of Arms was to remain unaltered for almost 25 years. When, in 1968, the County Borough of Sunderland was created from the former Borough Council and the Sunderland Rural District Council, with its clutch of outlying villages, the Coat of Arms remained the same. The old Rural District Council had its own, though this had many similarities with its larger neighbour and so its passing was scarcely noticed. •

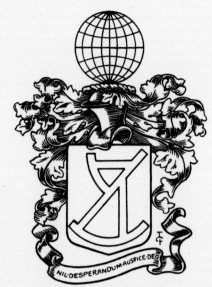

Unofficial Coat of Arms

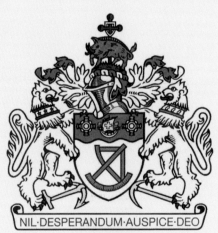

NIL·DESPERANDUM·AUSPICE·DEO

Coat of Arms 1974 – 1993

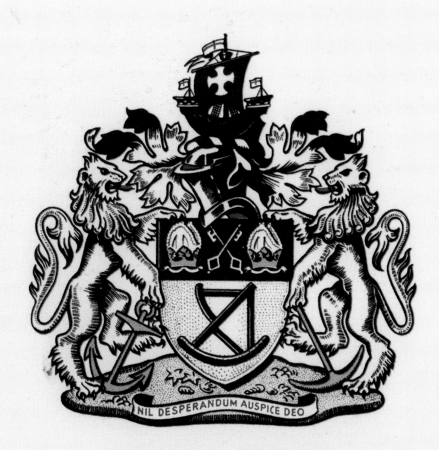

Coat of Arms 1949–1974

APOLOGIA

The Italian artist Cesare Pietroiusti says that art can have no excuse. What does that mean? Maybe we put too much onto 'meaning'. I do not want to juxtapose meaning and pleasure, but when we experience some part of nature wherein we are 'moved' do we demand to know the meaning of it?

Language kind of takes over our experiences and demands an explanation for art; but not for music.

Both Arne Naess (a Norwegian philosopher) and I have been impressed by how much meaning and intelligence there is in a symphony by Beethoven. But who would imagine to demand that this meaning be translated into language? Who even asks, "What is that symphony supposed to mean?"

There is a not-very-old tradition that visual art should illustrate texts; that its purpose is to illustrate. Although that kind of art quickly gets boring, it can sometimes work, if the artist is good enough. I'm afraid it does not work very well with Michelangelo; just ask yourself how interesting the marble carving of David would be if it were one half human size instead of twice human size, and if it had not the added weight of the story of David to fortify the soft marble. Michelangelo's 'David' is more of a Goliath. (I like to carve stone, but not marble, it is too soft and sugary.)

This tradition, of course, puts drawing and painting as the centre, foundation, and most authentic, of visual art.

Maybe some people should admit that what they mean is that painting and drawing are the most intellectually safe, and the most commercial. (Never mind that some other kinds of art now pull down very high prices; not much of it does, and the most bucks always go to painting.)

In my direct experience of the past forty years about every seven years the art magazines and papers announce that "painting is back", as though it had ever gone away. As though some other forms of visual art had been suppressing poor painting.

Especially in England critics like to accuse contemporary artists of not knowing how to draw. Really very often the same critics accuse artists of denigrating artists who can draw well. I have never met any of these artists, so I suspect neither have these critics. Most artists admire any talent or craft. And, perhaps, like me, then take it for what it is and not elevate it to a false level that can make you stupid and complacent.

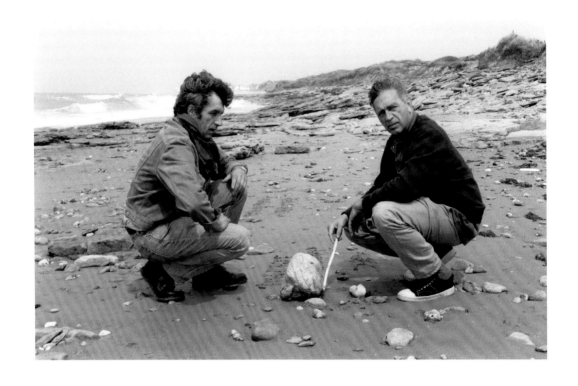

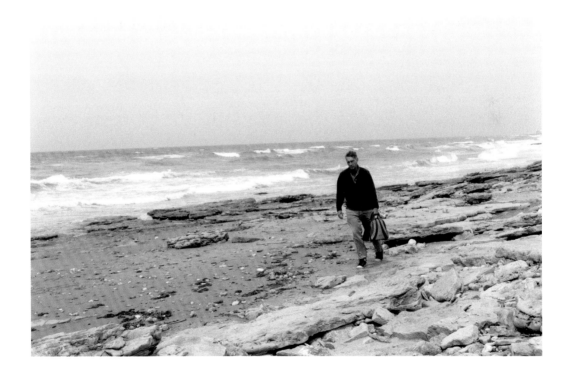

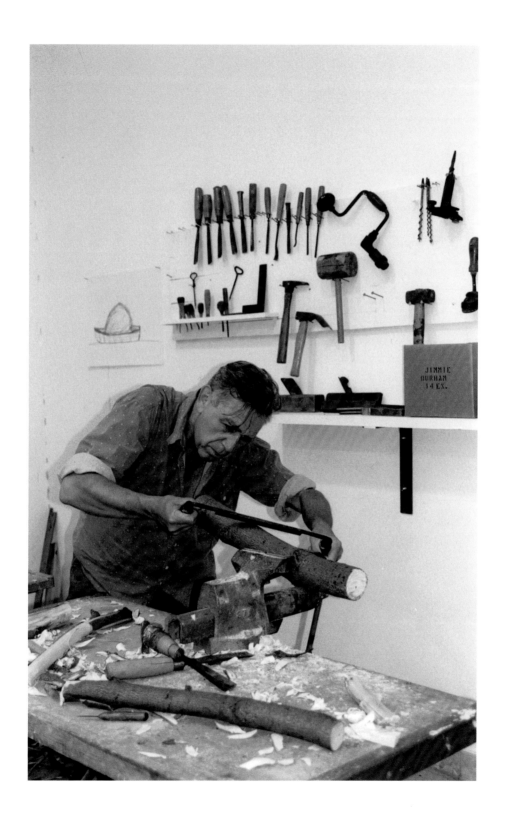

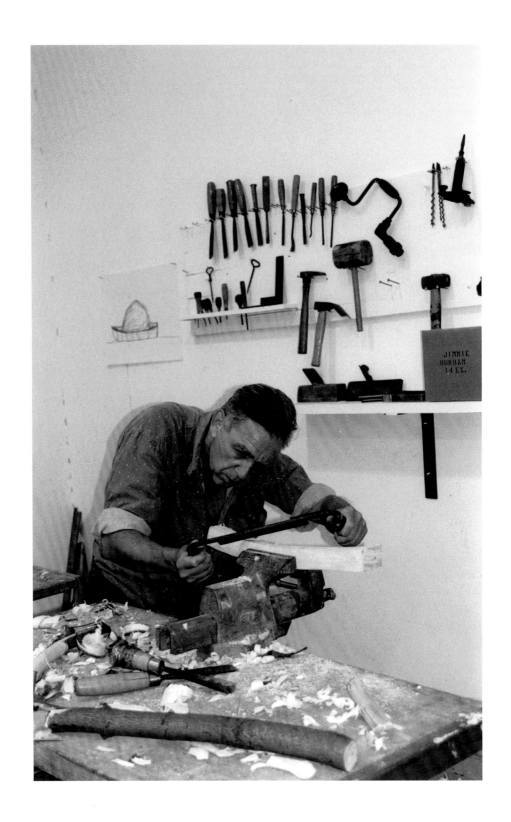

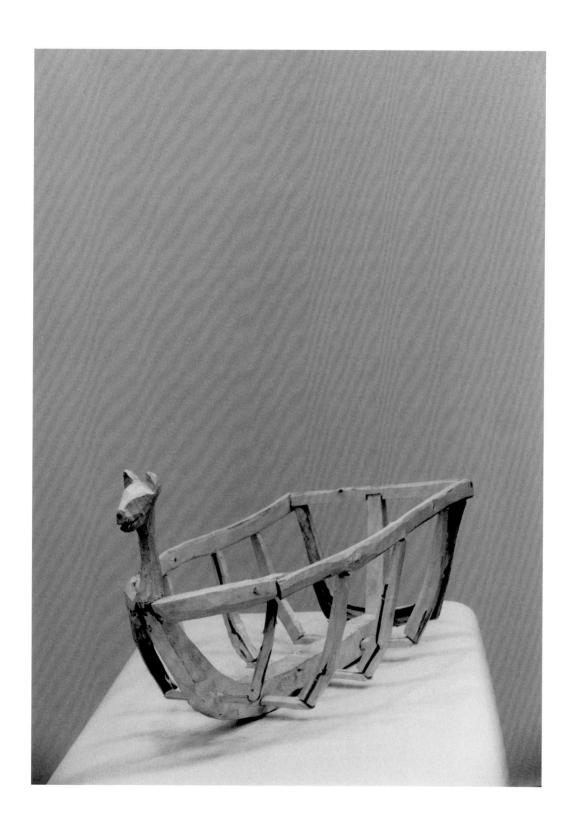

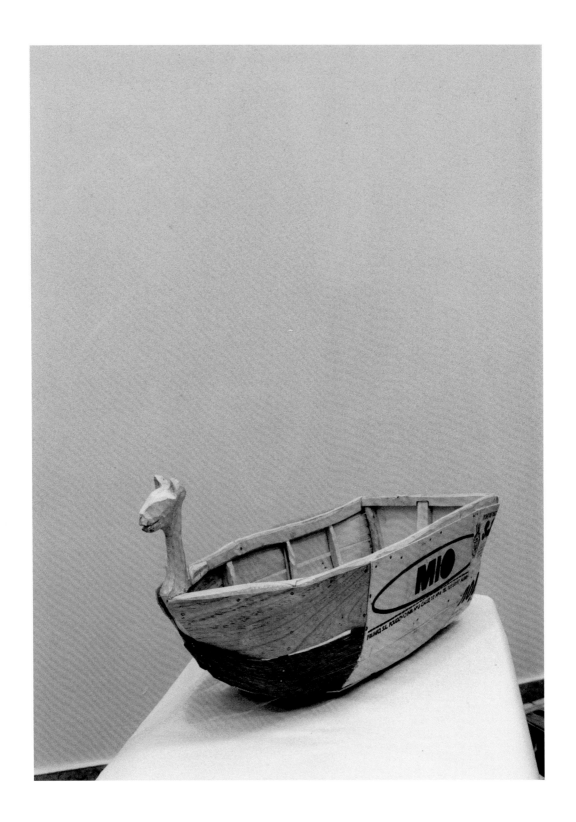

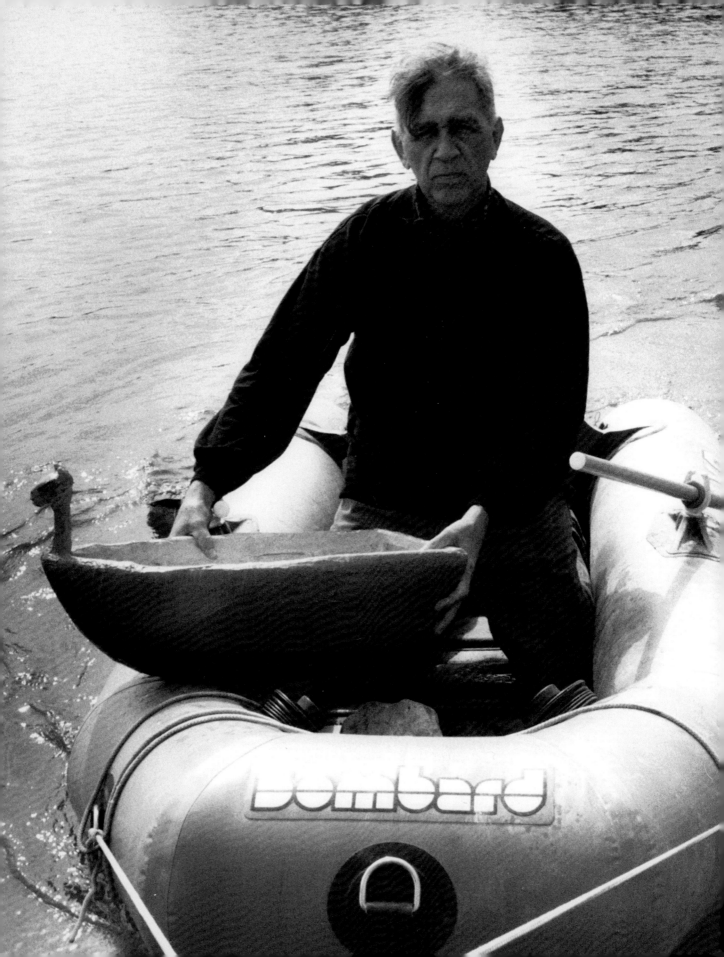

And yet, and yet — I am impatient with many curators and critics who promote kinds of art that are devoid of any content. The kinds of work that carry the sign of 'sophistication'. I suppose it is fear, fear of thinking or confessing the wrong thing in a very competitive job market, that makes people promote this stuff. Year after year work is promoted, I think, underline because it is empty. But expensively empty. Sophisticatedly empty. If there is something there we might embarrass ourselves by having the wrong opinion, so better to opt for work that is only aesthetical. I see that I am not writing well about this; I speak about it often, but privately, which means I don't need to take care of how to say things as much as one must in writing.

I mean, the commerce of the signs of sophistication must be basically like the commerce of hamburgers. (And, dear readers, don't forget that commerce is not the real foundation of hamburgers. I will sound like a stupid conservative, but I am only an anti-capitalist - - - when people started making hamburgers for sale they usually had the idea to make a very good hamburger, and that was the way to sell it.)

It really is true that everything is going to hell, isn't it? Because commerce, marketing, money, is the only criterion, isn't it?

But listen now, you bunch of fools: I hear some of you mocking me, and mis-representing what I said about experiencing nature. Well I was not comparing the experience of art with the experience of nature, OK?

Speaking of nature, however, Brian Foster of S'underland writes that the stone in the boat looks like Mr. Potato Head. Well there is a very good reason for that: protective camouflage. Potatoes camouflage themselves to look like stones. The hope is that any worm or grub passing by will think, "Oh, nothing to eat here, just a field of boulders." So it's not me copying Mr. Potato Head, it is potatoes copying stones.

Mr. Foster also claims that the piece will probably be "turned into a Viking funeral pyre".

Last night I wrote myself a note; "Valhalla — insect death traps." This morning I could not remember what the note is about. When I asked Maria Thereza she said that I had said that it was very important for this book, but not why.

At any rate, it surely has nothing to do with Brian Foster because I didn't read his letter to the *S'underland Echo* until this morning.

Valhalla is a bistro across the street from my flat in Berlin. In the summer they put tables out on the sidewalk and tie jars of sugar-water onto nearby trees. The jars have funnels on top so that insects, wasps, bees and flies, can get in but not out. I wish I knew why last night I saw a connection between that and the second 'Particle / Wave Theory'. The knowledge might explain some hidden motives or contradictions in my work.

The first 'Particle / Wave Theory' was made in Lisbon in 1999. (I think that date is right.) It is a small, well-made wooden boat painted red, a small table painted green, and about one hundred stones painted different shades of blue and placed in four large piles a bit away from the

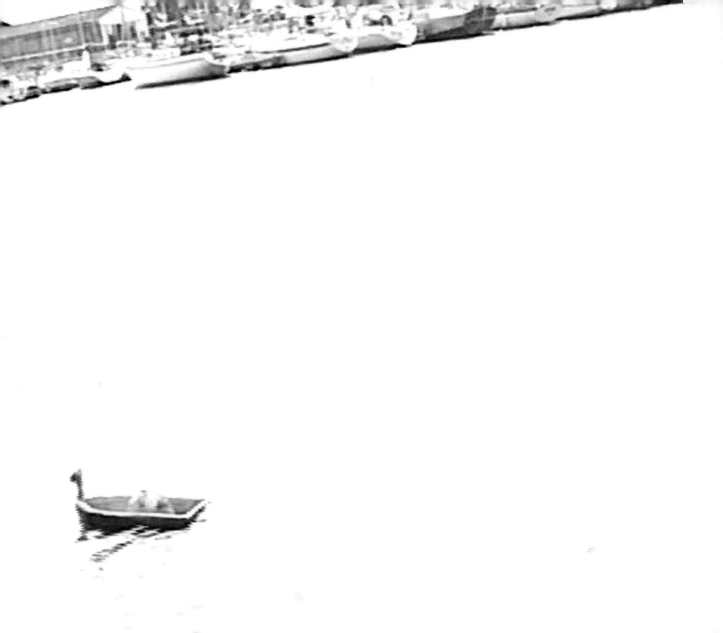

boat. There are two printed texts. One is a list of words in the Purepecha language and their English meanings. The other explains the work of a governmental committee in the state of Texas. This committee is called the Clemency Board — the mercy committee — and if you are given a death sentence by the court you must then appear before this committee and try to convince them that you should not be killed.

In its long history of service to the people, the Clemency Board has never granted clemency.

The second 'Particle/Wave Theory' has no text except this companion book, but the boat does have a name, 'Float Sam', which is inadvertently not painted on it, "Float Sam" as in 'flotsam and jetsam', which means those things more or less naturally floating in the water and those put there by a ship in distress, such as sail-masts, ship's stores and goods or various parts of furniture.

STILL APOLOGIA, DIFFERENT SUBJECT

Reg Vardy is an automobile dealer in S'underland and is quite successful. With some of his profits he has donated a gallery space to the art school of the University of S'underland and named it after himself. It is the Reg Vardy Gallery, where I recently had a show of which the second 'Particle/Wave Theory' was a non-integral part.

Someone to whom he might listen should advise Mr. Vardy and his family that he should call it simply the Vardy Gallery, so that there is no confusion as to selling cars and advertising car sales and showing art.

You might think I should have put Reg Vardy and his gallery under the heading, 'Materials Used', next to the Venerable Bede (local characters) but he is not really the subject of this part of Apologia.

It's my art show I want to talk about.

Maria Thereza's father (he's the same age as me, and once he had the New York City police and private detectives after me, but we are friends now) had the idea a couple of years ago to sell polished Brazilian semi-precious (oh, how I love that term!) stones in New York. He sent some to Maria Thereza to make photographs but then gave up the project, so I got some of the stones and used four of them in a work I made for the Reg Vardy Auto Sales Gallery.

Those four stones really were only to illustrate (in a non-illustrative way) a text which was the printed version of a speech I gave in Porto Alegre ('Happy Port') Brazil, earlier in 2005, at the World Social Forum.

It was my first visit to Brazil, even though in the 1970s I travelled all over South and North America <u>except</u> Brazil. There was no reason to go there; one could meet with Indian groups only with government permission, and the government was the military dictatorship. I was with the American Indian Movement; even with my pretty blue eyes they would not have allowed it, but even if they had, then what?

I went in 2005 because I thought there was a chance to start something. Gilberto Gil, one of Brazil's black singing stars, had become the minister of culture under the new government, and Maria Thereza had been the Brazilian Worker's Party's (the present government) first representative in the US in the early 1980s. Gil was on the panel where I spoke. The World Social Forum is really a good thing. Started by Brazil a couple of years ago, it instigates and promotes discussions that otherwise might not take place.

I thought I could use the forum to speak to Brazil. Here is the speech I gave:

> I want to try to speak to Brazil today. I want to speak to the people of Brazil, to challenge you; but in the spirit of solidarity. Here in Brazil there is a situation that must be seen as completely intolerable in the twenty-first century.
>
> In the legal system of Brazil Indigenous people are not regarded as human beings.
>
> Let me say it again: Brazil does not see the Indians of the country as fully human, with full human rights. People here say, "os nossos Indios", "os nossos Indios"! "Our Indians"!
>
> This situation exists nowhere else in the world. Indigenous peoples of the Americas are badly treated in every country, but only in Brazil are we legally seen as less than human.
>
> I know very well the excuse, the history and reasoning behind this phenomenon. I have heard the explanation from government officials and from anthropologists for more than thirty years.
>
> I am here to say that now you must change.
>
> Now Brazil has the opportunity to change.
>
> There has been no future in the Americas for five hundred years. The US, of course, has convinced much of the world that it has the future, when all it has is money and guns. Brazil now has the opportunity to make a new future in the Americas.
>
> There must be a better law. Indigenous peoples must be accorded full legal rights, human rights, as well as full protection under the law. No more 'parks', where Indigenous communities are treated like endangered species and no more landless Indians. Indigenous communities must have territories that are theirs by every right, and the right to economic and cultural development, education both in Portuguese and their own languages through the highest academic levels. Yet, there must be even greater protection of these communities from exploitation, an even greater legal protection of individual's rights and lives, but with no more paternalism.

Because of the horrible history, this is certainly complicated, and cannot be approached simplistically or without thorough involvement by all Brazilians.

Here are some possible ideas for a beginning: recently in Australia I witnessed and participated in a new social tradition. Aboriginals ask all Australians to begin any public address with a statement of recognition of which Aboriginal group once had the land. So that, for example, here in Porto Alegre I might have begun my talk by saying that I acknowledge that I am in the land of the Guarani. Australians also have a national 'Sorry Day', on which the general public is asked to apologise for treatment towards Aboriginals. Of course, there is racist mockery of the day, and much ignorant behaviour, but that can also serve, by its exposure.

One last thing: the São Paulo Biennale is known internationally. We imagine that if there had been a Johannesburg, South Africa Biennale during the 'apartheid', most artists would not have participated.

I am an American Indian, and stand before you to say that we are as human as you.

Why not boycott the São Paulo Biennale? How not?

Well, I glued that onto the piece with the four polished stones from Brazil.

All this year I have been talking about the possibility of this 'Anti-São Paulo Biennale', so it seemed appropriate to make it part of an art piece.

Here is another interruption of sorts: while I was in S'underland working on the show, the *Guardian* newspaper printed a story about two Brazilian Indians who were speaking at some nearby university. The article said that they were travelling with a 'companion', without mentioning that this 'companion' was a government chaperon and that the two Indians would not have been allowed to travel without him and could not travel anywhere except to the designated places with the government guard. Certainly the British anthropologist who arranged for them to be brought over did not advise them of their right to request political asylum.

So I sent the *Guardian* a letter asking them to print my Porto Alegre speech in their editorial and opinion pages, but they refused.

(A much lesser insult, one of their art critics, Robert Clark, wrote about one of two pieces I showed at the 2003 Venice Biennale. He wrote only that it was a piece of plastic tubing with a sign that read, "Please do not shit on me." Fair readers might forgive me if I take now the opportunity to straighten the record a little. The show was curated by the artist Gabriel Orozco, with the instruction that we would attempt to make spontaneous and quotidian pieces, things with a strange common-ness. I found a piece of grey PVC pipe that had so much pigeon dung on it it looked like a stalagmite formation.

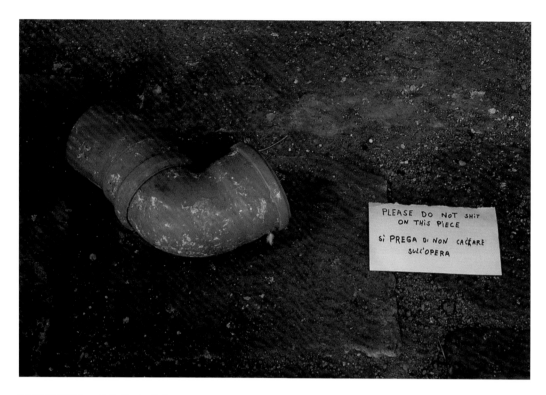

PLEASE DO NOT SHIT
ON THIS PIECE

SI PREGA DI NON CACCARE
SULL'OPERA

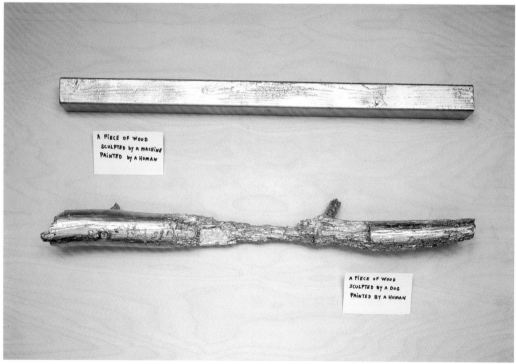

A PIECE OF WOOD
SCULPTED BY A MACHINE
PAINTED BY A HUMAN

A PIECE OF WOOD
SCULPTED BY A DOG
PAINTED BY A HUMAN

I then placed it along with the sign, not "Please do not shit on me." as Mr. Clark said but "Please do not shit on this piece." next to a work by another artist which had the warning, "Please do not sit on this piece." My real work in the show was called 'Homage to Robert Filiou', so I called the joke piece 'Homage to Robert Filiou 2', because I thought it had something of the spirit of some of Filiou's work. Mr. Clark didn't mention my other piece, which got actually a quite good response from the public.)

In general I like the *Guardian*. I started reading it in 1963 in Texas, as the *Manchester Guardian*. Imagine that the newspapers of Texas in those days were for cowboys. (There was another 'Guardian' newspaper in New York, founded by my friend Cedric Belfrage who was expelled from the US during the McCarthy witch hunt in the 50s. In Mexico just before he died he translated Eduardo Galeano's trilogy, 'Memory of Fire' into English. If you have not read that, you should. It is almost unbearably beautiful.)

In 2003, the *Guardian* published an obituary of Marcos Verón, a Kaiowa Indian leader in Brazil. That must be the first time that any major newspaper anywhere has published an obituary of an American Indian (except maybe for Jim Thorpe from the US who won so many Olympic gold medals).

Some people have asked why I want to start trouble for Brazil now, when there is a better government for the first time. That is certainly a good reason; other governments would not have listened at all.

But more, it is the 21st century. We ought to feel that it is intolerable for any country to make some of its people legally not considered fully human. It hurts us all.

Recently the Brazilian government declared that a fairly large tract of land would be given over as a 'parque' for several Indian communities. That does not mean that the land is given to the Indians. It is more like <u>they</u> are given to <u>it</u>. They have no legal rights to it (nor to anything) and may not develop it or make money from it, only live in it as park animals.

So some of the Indians kidnapped some government officials in protest, because they had been working for different white people for at least a little cash and if they lived in an 'Indian Parque' they could no longer work.

That every Indian community in Brazil should have a territory, rights and opportunities to education in their own language and in Portuguese, the right to economic development, the right to travel freely, to leave their communities for work, education or pleasure and to return of their own volition certainly should be considered minimum basic human rights.

It should also go without saying that local, state and national government must provide full protection against exploitation of any kind. Almost all of the European public (Sorry, Brits, but from my point of view you are all Europeans.) has agreed to the racist concept that the 'way of life' of Brazilian Indians must at all costs be protected, even if the cost is in Indian lives. The *Guardian* collaborates with anthropologists who collaborate with the Brazilian government's genocidal policies.

I know it is odd to mix these dire political situations up with art, even if the São Paulo Biennale started it. This book has parts in which I try to be funny, so it might seem out of place to throw in serious stuff. I can think of no excuse.

In the 1960s an artist from the US who died young, Gordon Matta Clark, was invited to participate in the São Paulo Biennale. He refused because of the military dictatorship, and thought about making an anti-São Paulo Biennale in Chile.

I offer no speculations about that.

Complications usually develop, don't they? I've just learned that the Spanish curator Rosa Martinez will be one of the curators of the next São Paulo Biennale. She is a friend I respect and admire. She does not know, as I write, that Indians are not legally humans in Brazil. She took the job in good faith, as others before have done (except Brazilians, who know this law).

If I were to advise her to resign, who benefits? If I help organize an anti-São Paulo Biennale for this coming Biennale, who benefits?

I will talk with Rosa.

She was a curator of the 2005 Venice Biennale. Some Xavante Indian 'Warriors' were in town, as part of a Brazilian theatre project. (Indians in Brazil are more and more used as tourist attractions.) The posters looked very sophisticated, contemporary theatre from Brazil. Almost no one knew, of course, that the Xavante men were essentially captives, brought there, just like the Indians who had visited the north of England, under government guard. Not free. The same as, except worse, the Indians who were brought to Venice a century earlier in Buffalo Bill's Wild West Show.

Indians in Brazil have tried to make their own national Indian organization. On behalf of the American Indian Movement in the US, Maria Thereza Alves tried in the early 80s to meet with one such organizer, Angelo Kretã, but he was killed before her trip was completed. The next year she did meet with another, Marçal de Souza, but he was also killed soon after.

These events are not unusual in any country in the Americas, but in Brazil — there is this intolerable legal hammer.

Monuments. Jen Budney, Maria Thereza and I tried to get a conference going here in Berlin, about monuments. We thought Berlin would be a good place because of its history, monuments, and all sorts of new public art projects.

We wanted most of the participants to be Indians from the Americas. Monuments are everywhere markers for belief and death, but in the Americas they are so often specifically against us. They celebrate our subjugation and supposed disappearance.

Couldn't get any interest in Berlin, though. The project sunk into the mud.

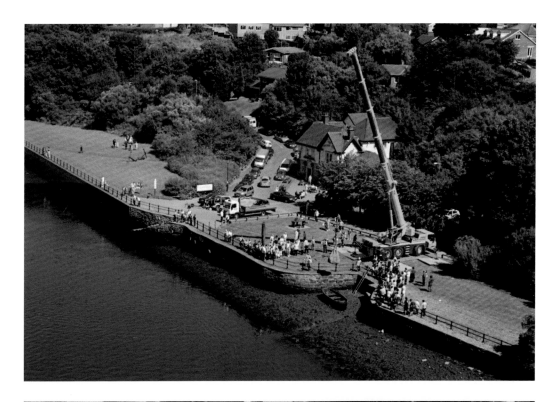

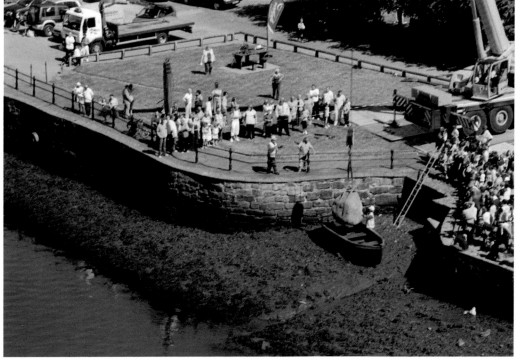

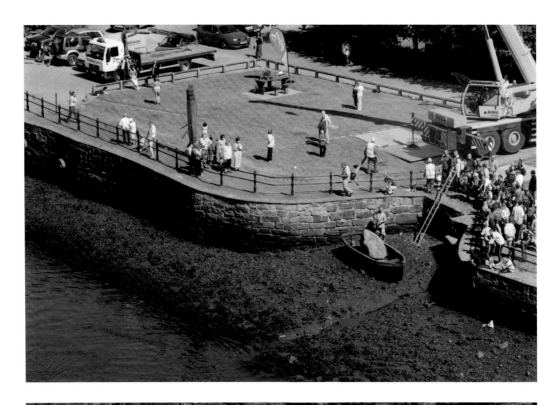

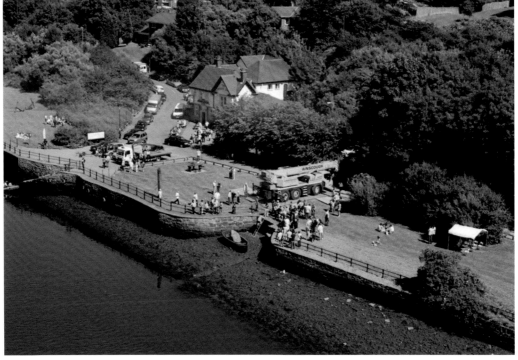

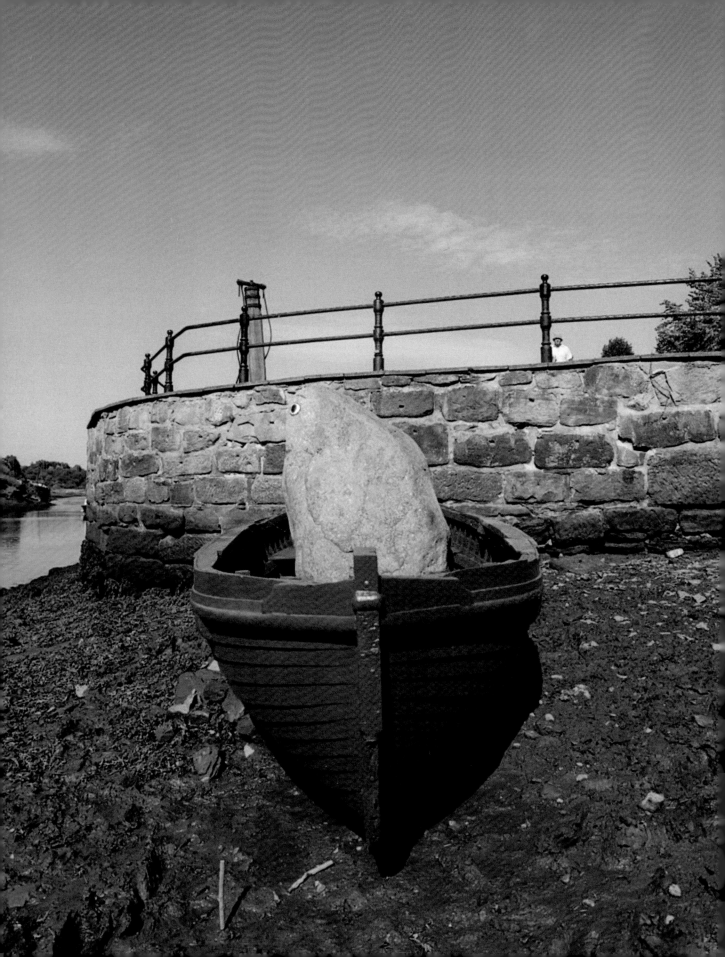

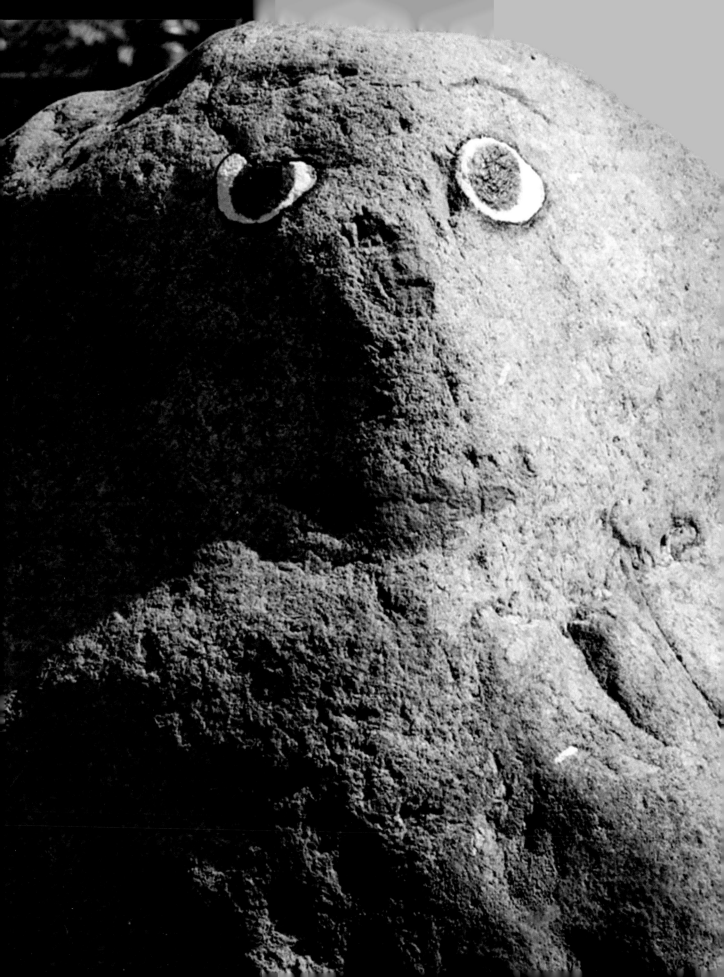

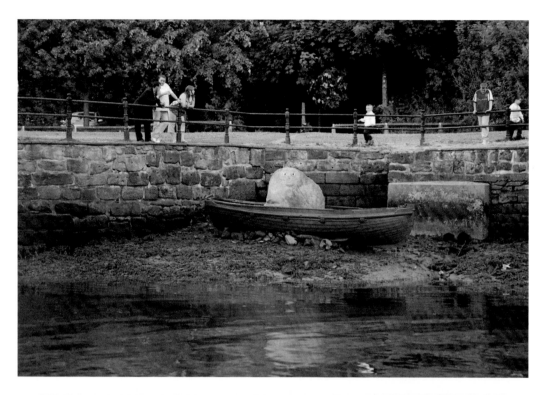

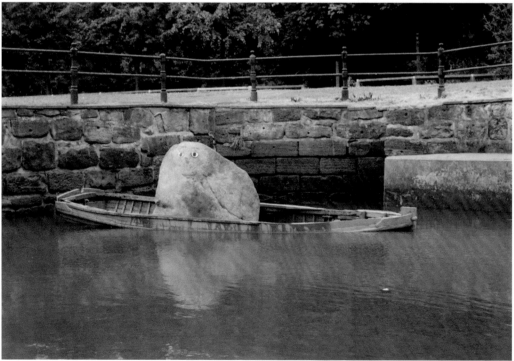

Well, some people have said that anyone can get a boat and a boulder and paint a face on it and call it art. We could try to make a deal. OK, aside from the thousands of pounds that were wasted on the second 'Particle/Wave Theory', what if we don't call it art? Especially in England and the US people often get upset about things being called art, including some paintings, when they do not look like art. Why can't we all just agree that art means well-executed painting and sculpture that looks like something in the real world (and not people's genitals, either)? All the other stuff could be called epirogeny. I have practised epirogeny for forty years, and can tell you that the life of an epirogenist takes great scirrhous scission and 'huitzazatle', as the French say. See? It's OK, isn't it?

Another thing: what's wrong with wine and cheese? Even in the epirogeny world there are so many people, again, especially Brits and Yanks, who make fun of epirogeny openings.

What is wrong with dressing up, meeting socially and drinking wine with little things to eat? What's wrong with doing that while celebrating the latest work of an epirogenist?

In Sydney an old guy came up to me and said, "That's a waste of a perfectly good stone."

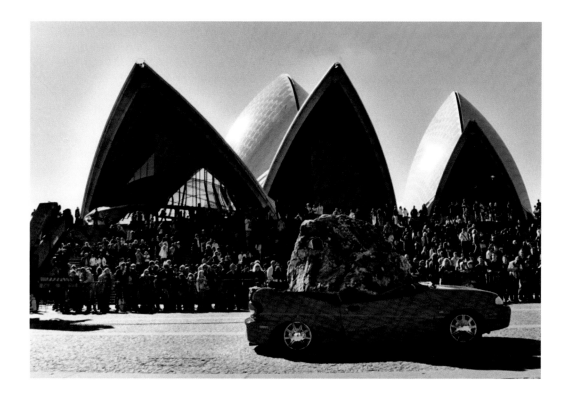

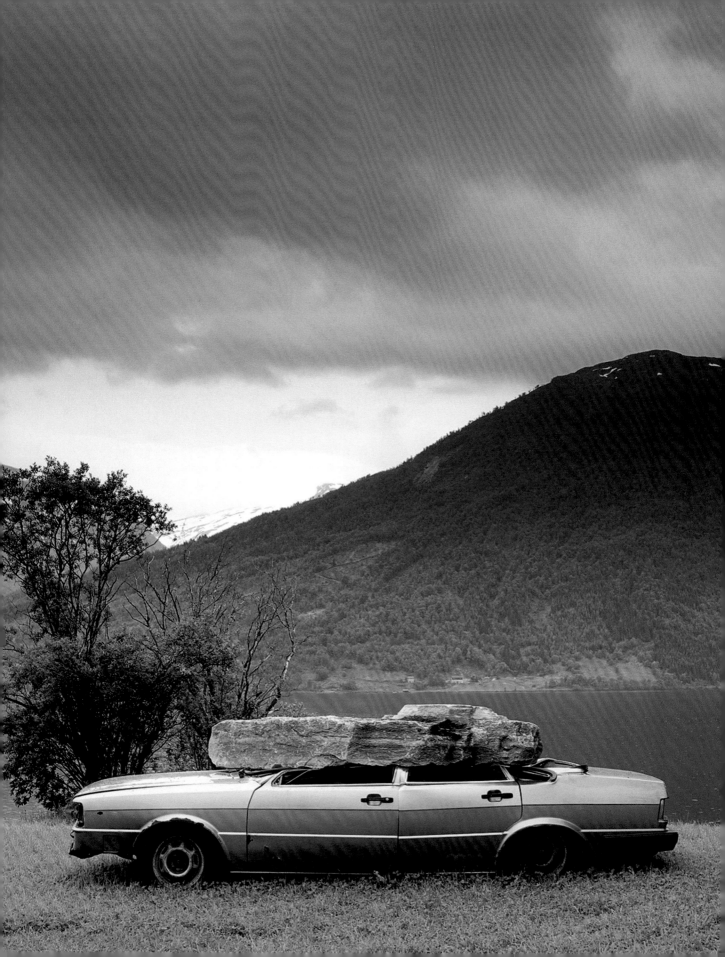

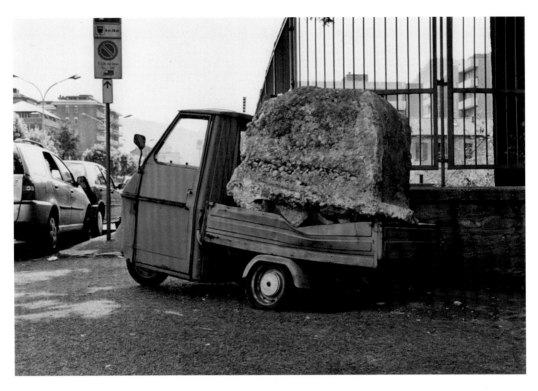

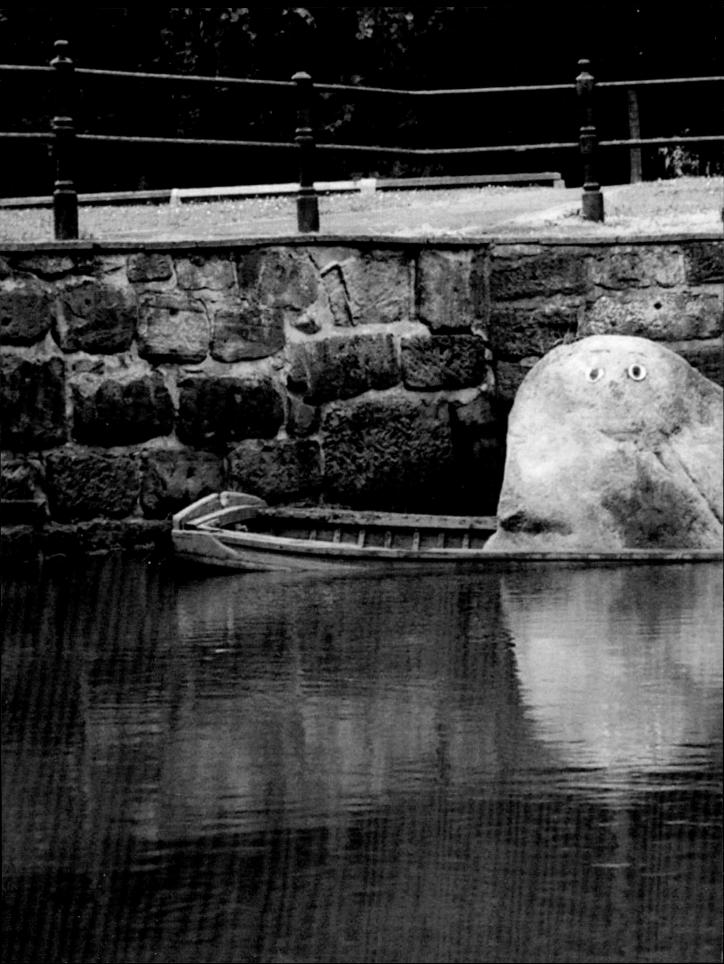

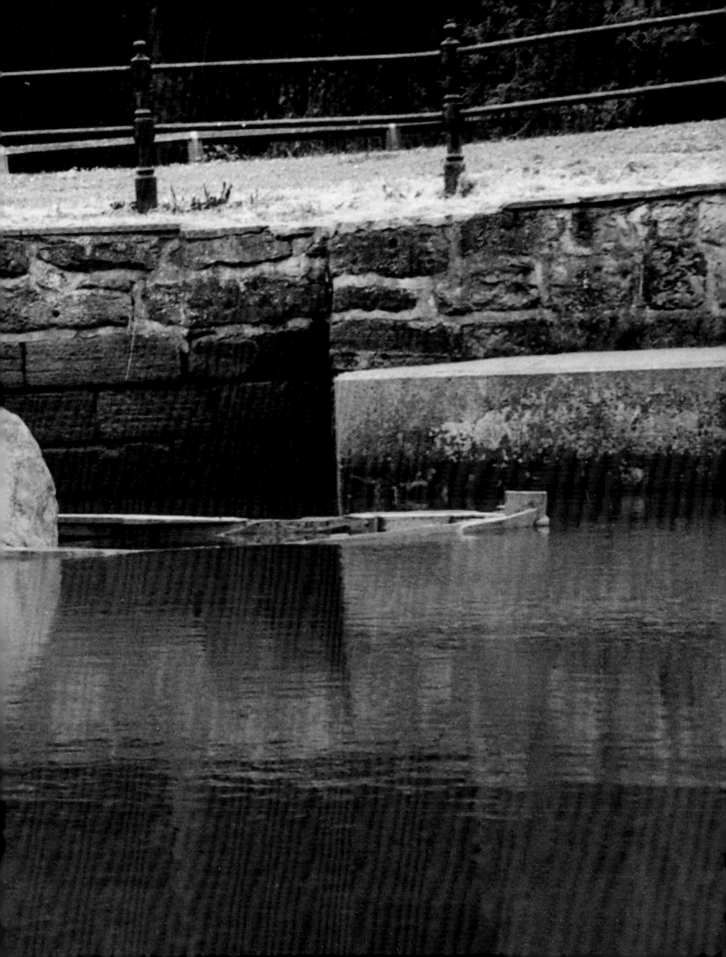

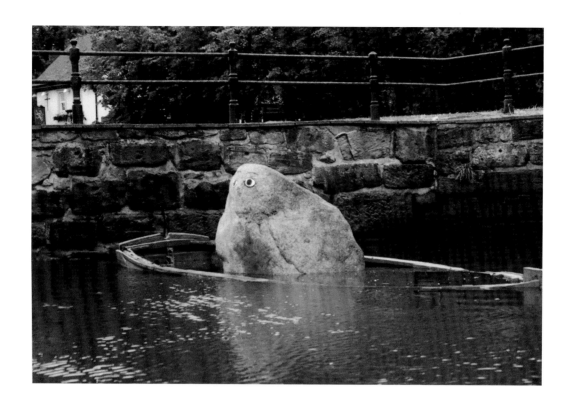

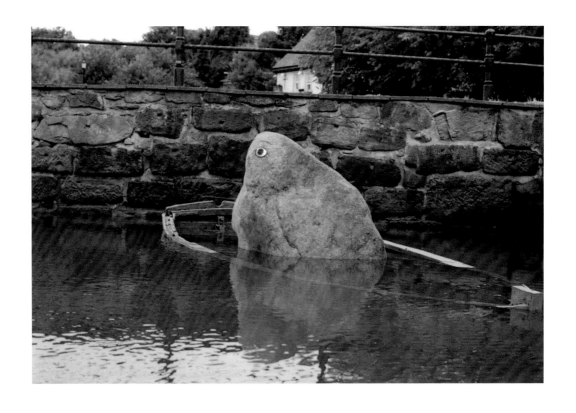

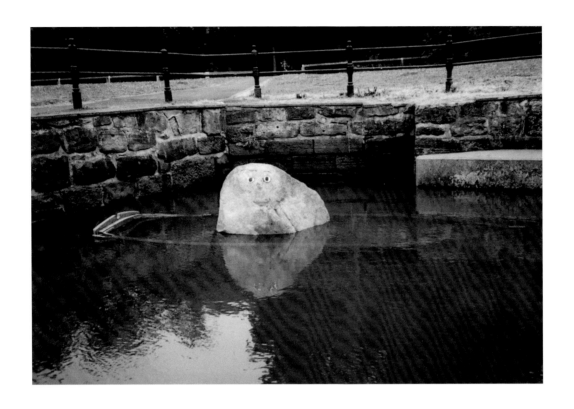

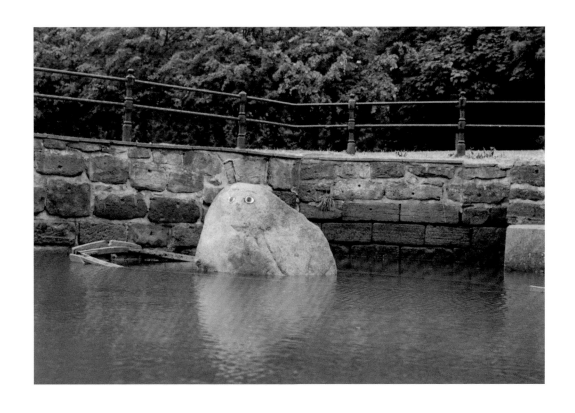

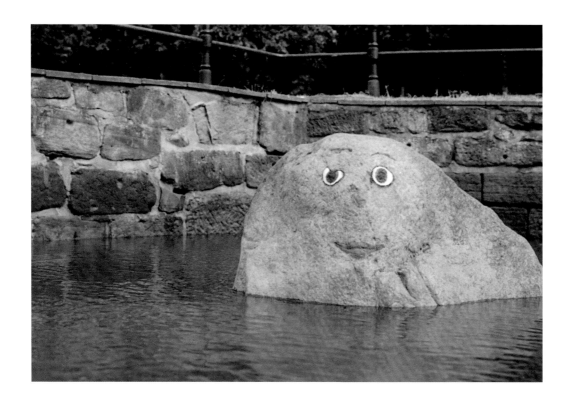

Any 'particle/wave theory' must allow for an element of non-sequituration, or unmeasurable scirrhousity, and in S'underland a real golden lion was once found roaming about. His skin is now stretched over some lion-shaped plaster in the City Museum. (That is part of a ceremony the English share with other Saxonic peoples.) No one seems to remember the full story of the lion. It scares some small children. Some adults assure them that there are certainly and absolutely no more lions in the city. Well, adults would, wouldn't they?

The Golden Lion Public House has situated itself near the second 'Particle/Wave Theory' non-monumental epirogeny work, by the old ferry landing. (They are now offering Stone's Bitter for sale.) I asked the proprietors if they had owned or killed the original Golden Lion.

The boss, or maybe she is the boss's wife or just a friend, is a very pretty blond woman. We do not completely understand each other's English, but I think she said, "We never realized your big rock has a face on it. You put the face toward the river so we'd need to be in a boat, wouldn't we, to see what sort of thing you were up to? It's only now when you bring this book around, looking for a free Stone's Bitter, that I can see the real complexity and pathos of what you've done."

ENDNOTES

[1] Please see 'Yellow George'.

[2] Please see 'Golden Lion' at the end of this book.

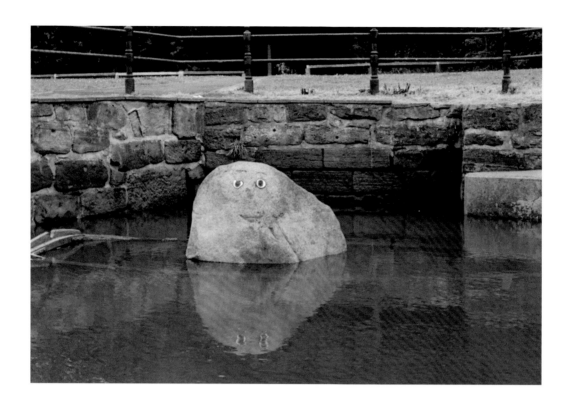

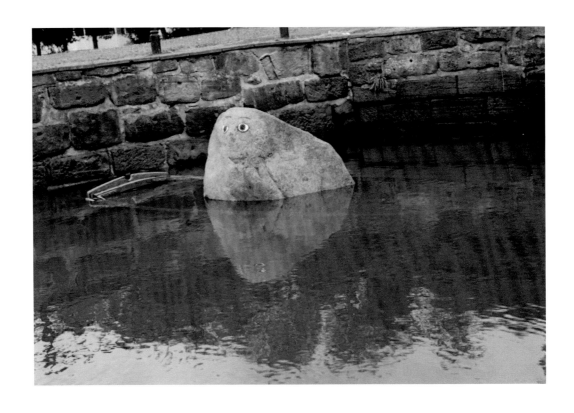

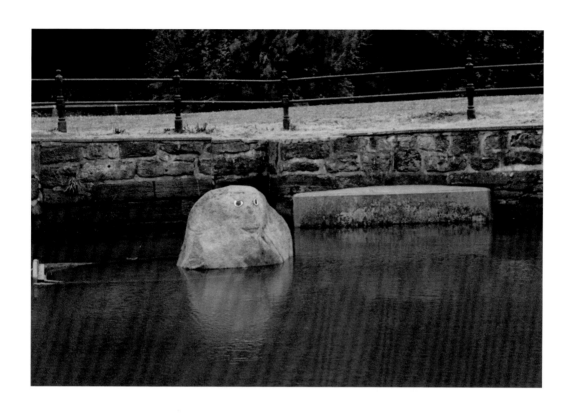

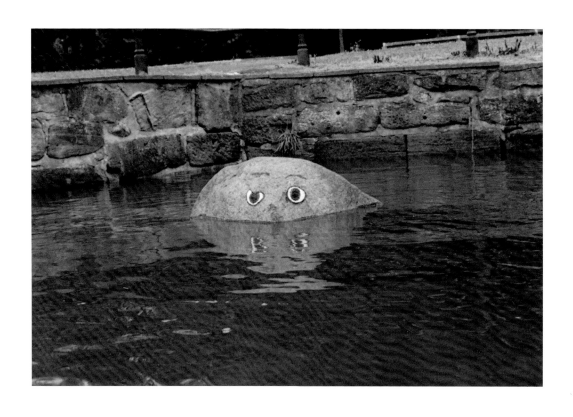

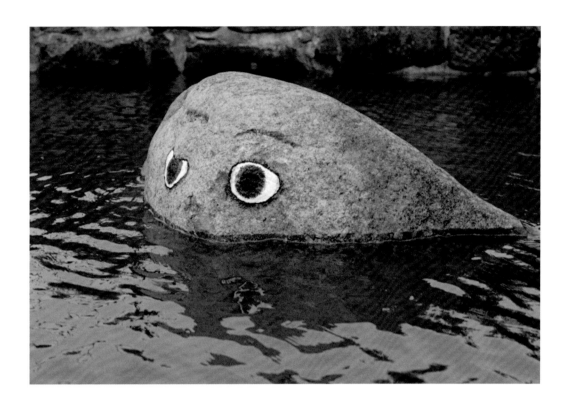

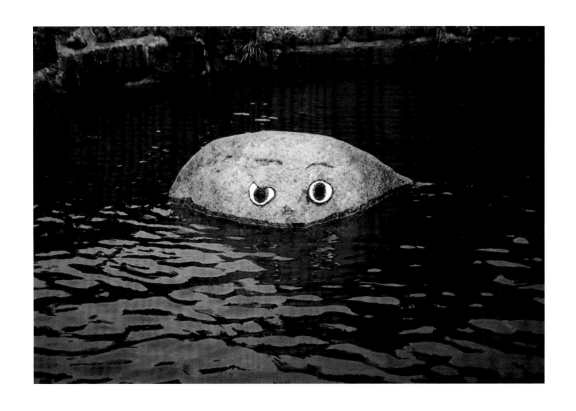

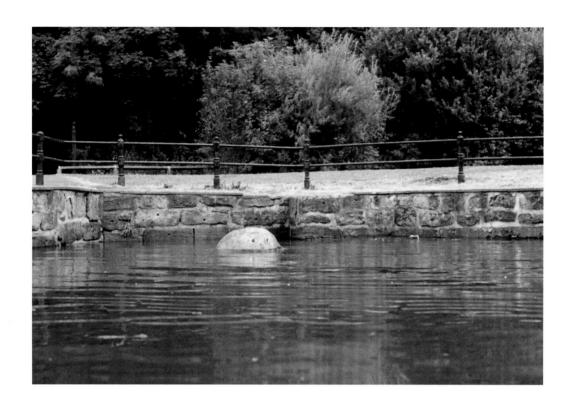

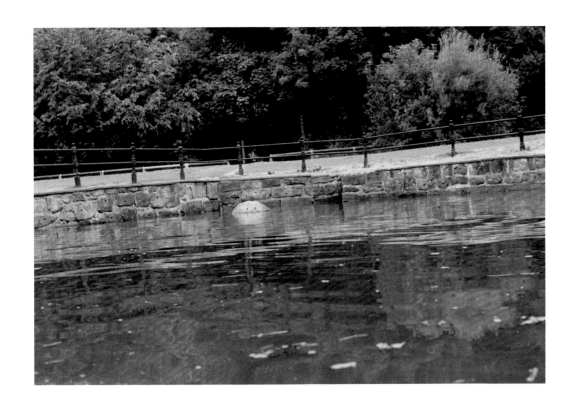

THANKS

My sincere and heartfelt gratitude to many helpful people in and around Sunderland. A good spirit everywhere.

Special thanks to Marian Downes, Ken Barella, Eric Bainbridge, Gary Brown, the Ainscough crane crew and drivers.

The staff at the Sunderland University Art School, the staff at the Golden Lion Pub.

The most efficient photographers Christina Freke, Nigel Davison, Nicola Maxwell, and Graham Mitchinson.

The two curators who have become good friends, Robert Blackson and Candice Hopkins.

To Brian Foster and Robert Clark for generously allowing me to quote their sharp criticisms.

As always to Maria Thereza Alves, *alma di mi corazon*.

Section Four

Not a lot of people know this.......

After Her Majesty Queen Elizabeth II was married in 1947, Maggie Beattie received a parcel from Buckingham Palace. It contained everything needed to make a fruit cake, including a tin of butter. The letter enclosed with the ingredients explained that the Commonwealth Countries had sent all the ingredients for the then Princess Elizabeth's wedding cake and the surplus was being distributed to pensioners. Maggie often wondered why she had been chosen to be a recipient. It is possible that there are other families in the village whose relatives had received similar parcels.

British Weightlifting Champion Syd Davey once did a "handstand" on the top of the "old" Paper mill Chimney.

There was no record of any big crimes in the village in the early 1960s. The village Constables seemed to have been on friendly terms with the villagers, some of whom committed petty crimes and accepted their punishment when found out. But not all were found out as the following true story shows.

A pig had been killed and stolen, and all evidence pointed to a certain man as the guilty person. The village constable arrived at the man's house with a search warrant, but only the good wife and the baby were at home. She was quite willing for him to carry out his duty but asked him to search quietly as she was trying to hush the baby to sleep. She rocked the cradle and hushed the well-covered baby while the constable searched in vain and went away. Then the good wife took the pig from the cradle and all was well.

76

(Jimmie Burton)

By the same Author, in 5 vols. crown 8vo, with 9 Steel Portraits
and 342 Illustrations on Wood, 7s. 6d. each.

LIVES OF THE ENGINEERS;

WITH AN

ACCOUNT OF THEIR PRINCIPAL WORKS,

INCLUDING A

History of Inland Communication in Britain, and the Invention and
Introduction of the Steam-Engine and Railway Locomotive.

A New and Revised Edition.

VOL. I.—EMBANKMENTS AND CANALS—VERMUYDEN, MYDDELTON,
PERRY, BRINDLEY.

II.—HARBOURS, LIGHTHOUSES, AND BRIDGES—SMEATON AND
RENNIE.

III.—HISTORY OF ROADS—METCALFE AND TELFORD.

IV.—THE STEAM-ENGINE—BOULTON AND WATT.

V.—THE LOCOMOTIVE—GEORGE AND ROBERT STEPHENSON.

*** Each volume is complete in itself, and may be had separately.*

OPINIONS OF THE PRESS, etc.

ON THE FIRST, SECOND, AND THIRD VOLUMES.

"A chapter of English history which had to be written, and which, probably, no one could have written so well. Mr. Smith has obtained a mass of original materials. It is not too much to say that we now have an Engineers' Pantheon, with a connective narrative of their successive reclamations from sea, bog, and fen; a history of the growth of the inland communication of Great Britain by means of its roads, bridges, canals, and railways; and a survey of the lighthouses, breakwaters, docks, and harbours constructed for the protection and accommodation of our commerce with the world."—*Times.*

"We cannot but refer in passing to the captivating and instructive volumes which Mr. Smith has devoted to the 'Lives of the Engineers,' a record not before attempted of the achievements of a race of men who have conferred the highest honour and the most extensive benefits on their country. 'Who are the great men of the present age?' said Mr. Bright in the House of Commons,—'Not your warriors—not your statesmen; they are your Engineers.'"—*Edinburgh Review.*

"Mr. Smith has profoundly studied, and has happily delineated in his lucid and instructive biographies, that remarkable succession of gifted minds which has, not by lucky guesses, but by incessant labour and by lifelong thought, gradually erected that noble example of dominion of man over the earth—the science of Engineering; and we are proud to know that there are men yet among us who can wield the arms of the invincible knights of old, and who will leave no meaner memory behind them."—*Quarterly Review.*

"Mr. Smith may fairly claim the merit of having produced one of the most interesting and instructive works. He has discovered almost unbroken ground, and has worked it

This book has been published on the occasion of the exhibition *Jimmie Durham: Knew Urk* and the public project *Particle/Wave Theory #2* organised by the Reg Vardy Gallery and Walter Phillips Gallery.

Text and Book Concept: Jimmie Durham
Introduction: Robert Blackson and Candice Hopkins
Editors: Robert Blackson and Candice Hopkins
Design: Vangool Design & Typography
Photography Credits:
Pages 6, 7, 18, 35, 36, 37, 38, 39, 40, 57 (bottom) Maria Thereza Alves
Page 24 Candice Hopkins
Page 47 (top) Courtesy the artist and Pat Binder and Gerhard Haupt
Page 47 (bottom) © Roman März
Page 55 Jenni Carter
Page 56 Courtesy Ole Martin Lund Bø
Page 57 (top) © Giulio Bruno, Studio Blu
Pages 25, 26, 28, 52 ©Christina Freke, 2tone Creative Photography
Pages 27, 53, 54 (top) © Nigel Davison, 2tone Creative Photography
Pages 50, 51, 58, 61, 63, 64, 66, 68, 69, 70, 72, 73 © Nicola Maxwell
Page 54 (bottom), 59, 60, 62, 67, 71, 80 Robert Blackson
Printing: Friesens Printed in Canada

The artist and authors would like to thank the South Hylton Local History Society for their kind permission to reproduce excerpts from South Hylton Recalled *(ISBN 1-900456-13-3)*

Walter Phillips Gallery Editions is the imprint of the Walter Phillips Gallery and Art Editions North is the imprint of the Reg Vardy Gallery

First published in 2005 by Walter Phillips Gallery Editions, The Banff Centre, and Art Editions North c/o School of Arts, Design, Media & Culture, University of Sunderland, Ashburne House, Ryhope Road, Sunderland SR2 7EF t. 0191 515 2128
www.regvardygallery.org

Distributed in North America by
Walter Phillips Gallery, The Banff Centre
107 Tunnel Mountain Drive, Box 1020, Stn 14
Banff, AB, T1L 1H5, Canada
tel: 1 403 762 6281
fax: 1 403 762 6659
email: walter_phillipsgallery@banffcentre.ca
www.banffcentre.ca/wpg

Distributed in the UK and Europe by
Cornerhouse Publications
70 Oxford Street, Manchester M1 5NH, England
tel:+ 44 (0) 161 200 1503
fax: +44 (0) 161 200 1504
email: publications@cornerhouse.org
www.cornerhouse.org/publications

Library and Archives Canada Cataloguing in Publication

Catalogue of an exhibition held at the Reg Vardy Gallery, University of Sunderland, and the Walter Phillips Gallery, Banff, Alta., to accompany the sculptural performance of July 16, 2005 on the River Wear.

ISBN 1-894773-23-3

1. Durham, Jimmie--Exhibitions. 2. Performance art--Exhibitions.

I. Hopkins, Candice, 1977- II. Walter Phillips Gallery III. Reg Vardy

Gallery IV. Title. V. Title: Second particle / wave theory.

N6537.D874A4 2005 709'.2 C2005-905289-9

The Walter Phillips Gallery and the Reg Vardy Gallery sincerely express their appreciation to the University of Sunderland, Culture 10, The Arts Council of England, Art Editions North, the Government of Canada through the National Arts Training Contribution Program of the Department of Canadian Heritage and the Canada Council for the Arts for their generous support of this publication.

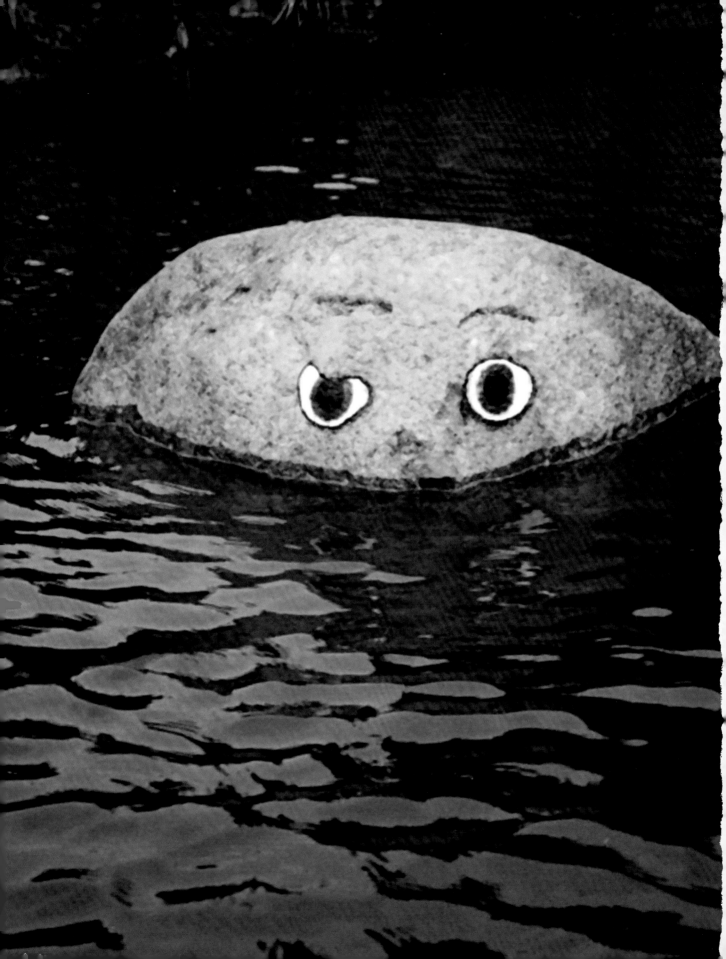